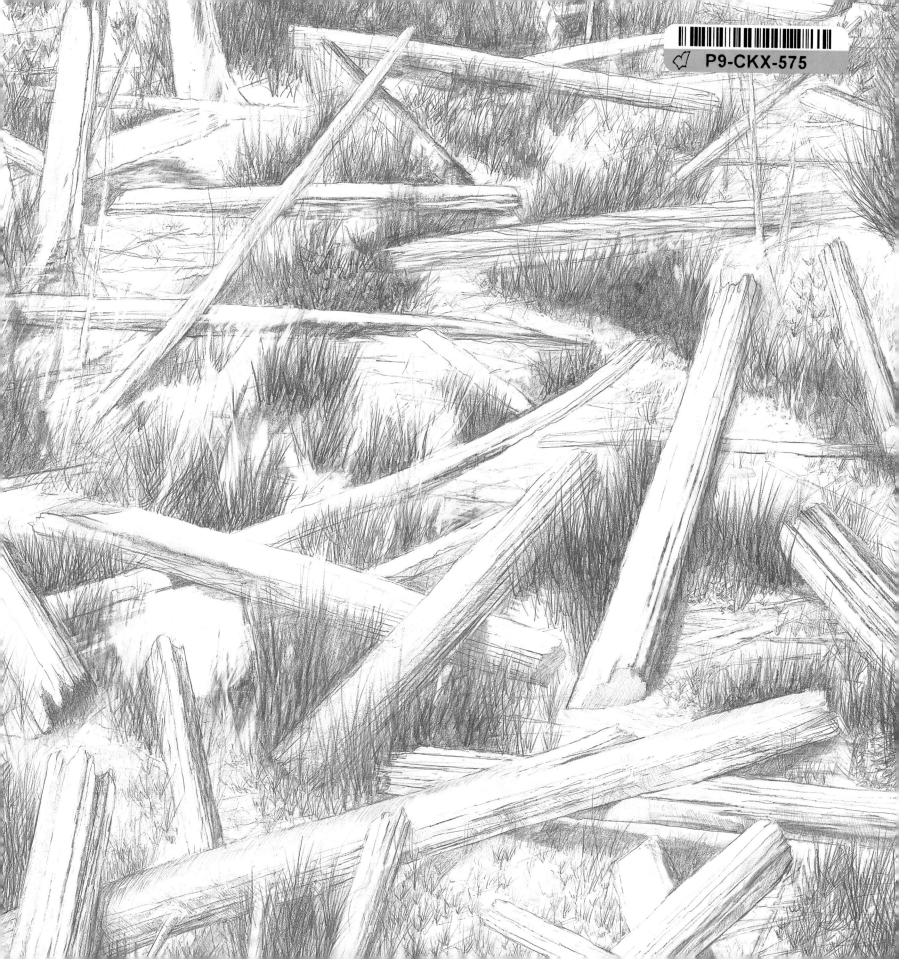

P9-CKX-575

WILLIAM INGHAM

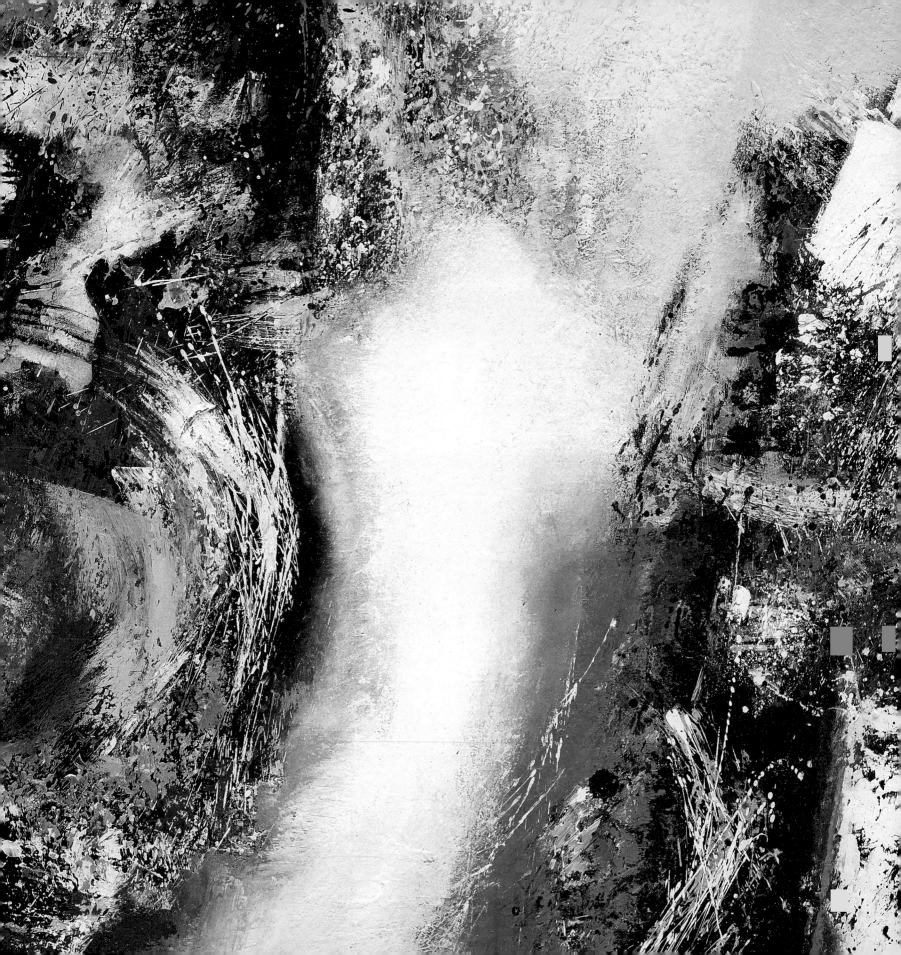

WILLIAM INGHAM

Configuration of Forces

MATTHEW KANGAS

Gordon Woodside Editions
distributed by the University of Washington Press
Seattle and London

© 2002 by William Ingham
Text © 2002 by Matthew Kangas

All rights reserved. No part of this book may be reproduced or used in any form or by any
means, electronic or mechanical, including photocopying or recording, or by an information
storage or retrieval system, without written permission from the publisher and copyright
holders except for purposes of reviewing the book.

All works by William Ingham, courtesy of the artist and Gordon Woodside/John Braseth
Gallery, unless otherwise noted.

All dimensions in inches; height precedes width.

Cover: *Prince Roman* (detail), 1992, acrylic on board, 33 x 23
Back cover: *Natural Color*, 1989, oil on board, 23 x 19
Frontispiece: *Winter Fall* (detail), 2002, oil on canvas, 18 x 20

Distributed by University of Washington Press
P.O. Box 50096
Seattle, Washington 98145

ISBN 0-295-98283-7

Designed by Phil Kovacevich/Kovacevich Design
Edited by Patricia Kiyono
Copyedited by Laura Iwasaki

Gordon Woodside Editions
Gordon Woodside/John Braseth Gallery
1533 Ninth Avenue
Seattle, Washington 98101
Tel: 206-622-7243

Printed in Canada by Hemlock Printers, Ltd.

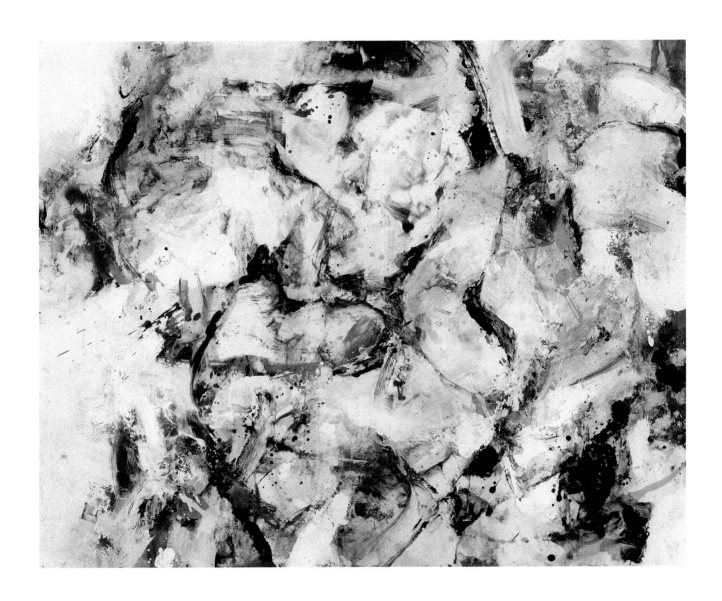

Untitled, 1976, oil on paper, 13 x 22
Seattle Art Museum, 76.16, Gift of Gordon W. Ingham

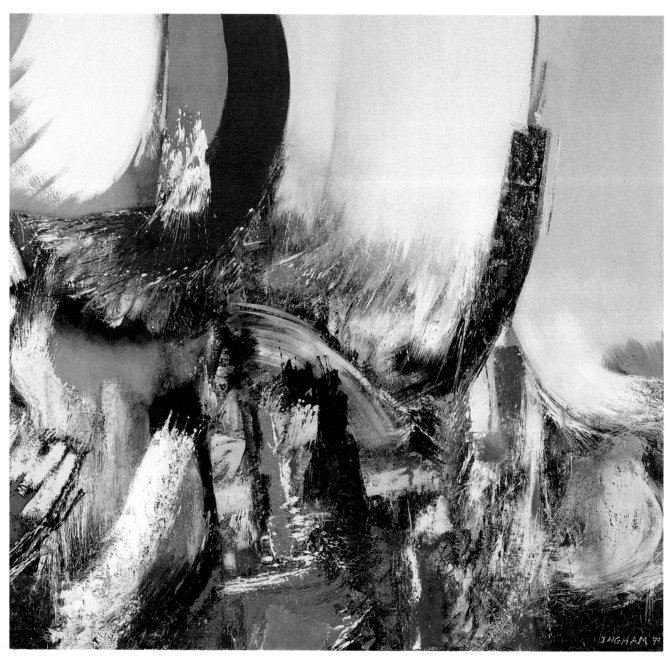

Mirage, 1999, acrylic on canvas, 62 x 66

WILLIAM INGHAM

Configuration of Forces

The art of Seattle-born artist William Ingham, a hybrid of East and West Coast influences, attained individuality gradually over thirty years. A former student of philosophy, Ingham approaches art with a seriousness of purpose that complements his studio practice of spontaneous improvisation. Although his abstract style has been associated with the work of the New York School (represented by Jackson Pollock, Willem de Kooning, Mark Rothko, Franz Kline, and others), Ingham imitated no one. He arrived at a variant of Abstract Expressionism slowly, consciously, and deliberately. He has always been out of step with contemporary art trends. Ingham developed as a painter in the 1970s, when the possibilities for young artists seemed limitless. Abstract Expressionism had declined after dominating American art throughout the 1950s and 1960s, and Pop Art, Earth Art, Conceptual Art, and Minimal Art all seemed like fertile new territory. Not concerned with trends, Ingham developed his individuality as an artist within Abstract Expressionism's conventions.

This essay explores the artist's evolution, development, and refinement of a distinct version of gestural abstraction. No slavish imitator, Ingham has struggled to effect his own vocabulary of painterly marks, compositional strategies, and aesthetic positions in constructing a nonrepresentational work of art.

Although Ingham was confronted by skepticism from fellow graduate-school classmates, who called his efforts "run-on painting," he quickly warmed to the isolation that set him apart from classmates who "pored over every issue of *Artforum* seeking something to paint."[1] Studies in philosophy at Colby College in Waterville, Maine, and Case Western Reserve University in Cleveland led Ingham to realize that what constitutes beauty in a work of art is not fixed but fluid. Yet much of the writing about abstract art that he encountered in his aesthetics courses and private study still defined abstract art as rooted in an identifiable image from which something was distilled or abstracted. In the case of Willem de Kooning (1904–1997), the artist to whom Ingham is most frequently compared, the figure and, later, the landscape serve as jumping-off points for the painting; images are corrected, submerged, or obliterated but somehow subliminally present. In a crucial difference, Ingham's art reveals no readily recognizable image.

Developing his art when more severe forms of abstraction were on the rise, Ingham benefited from Minimal Art's more aggressive rejection of imagery. He also appreciated the darker wing of the New York School, chiefly Mark Rothko (1903–1970), Barnett Newman (1905–1970), and Clyfford Still (1904–1980). In their work, the autonomy of the painting is what matters most; they did not make distant allusions to the visible world but issued stern proclamations of painting's right to exist as an independent aesthetic object.

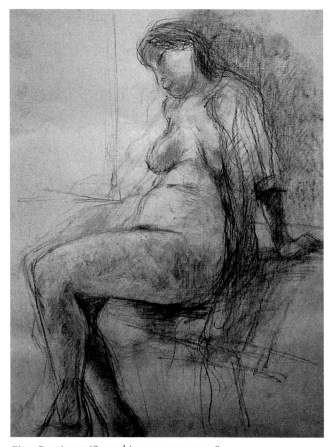

Figure Drawing, 1968, graphite on paper, 24 x 18

Ruth and William Ingham at Ostería del Orso, Rome, 1969

Ingham was steeped in the aesthetic theories of Goethe and Immanuel Kant; he also read Existentialist writers such as Jean-Paul Sartre and the phenomenological philosopher Maurice Merleau-Ponty, whose final essay "Eye and Mind" is highly applicable to the perception of abstract art.[2] At the same time, the analytic approach of Ingham's graduate-school professors at Case Western Reserve kindled his intellectual interest in the nature of beauty.

Rudolf Arnheim's writings in *Visual Thinking* and *Art and Visual Perception* became crucial texts for the young graduate student.[3] While Arnheim's views on abstraction do not go so far as to encompass wholly nonrepresentational art, Ingham found great intellectual nourishment in the émigré philosopher's ideas about form, ornament, orientation, and abstraction. In "Pictures, Symbols and Signs," a 1969 essay in *Visual Thinking*, Arnheim stated, "A painting…is intended to evoke the impact of a configuration of forces"—a comment that explains a great deal about William Ingham's art. With their dense webs of curves, lines, gestures, and swirling paint, Ingham's canvases suggest a configuration of forces come into play in the private sanctity of the artist's studio. Rejecting critic Harold Rosenberg's theory of "action" painting in what became the all-too-public "arena," Ingham was freed by his comparative geographic isolation and temporal separation from the New York School. He could assemble the elements or "forces" required of each painting without interruption.[4] Rather than Rosenberg's arena for action painting, Ingham turned to a different model—Rothko's

definition of painting as "drama," a highly private drama. As Rothko wrote in "The Romantics Were Prompted":

> I think of my pictures as dramas: the shapes in the pictures are performers.... Neither the action nor the actors can be anticipated, or described in advance. It is at the moment of completion that in a flash of recognition, they are seen to have the quantity and function which was intended.... The pictures must be...a revelation, an unexpected and unprecedented resolution of an eternally familiar need.[5]

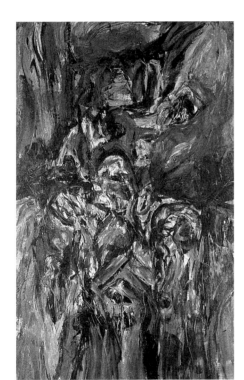

Francis Celentano (b. 1929), *Inferno*, 1960, oil on canvas, 60 x 37

Working in a succession of downtown Seattle studios since 1972, when he left the University of Washington School of Art, Ingham has slowly consolidated his interest in what a painting should be with his skills in creating one. Eye and mind are wedded to hand. The apprehension of an Ingham painting entails the same sort of revelation Rothko called for, without any perceivable trace of preordained plan or system. Treating painting as the pathway to discovery—of forms, colors, gestures, scale—Ingham has accomplished a body of work that, while widely collected, has not received the analysis or critical understanding it deserves. Bearing

in mind the artist's unique background as a philosophy student with an interest in art who has been a full-time working artist for the past thirty years, let us examine the development of his art—its debts and discards, its breakthroughs and considerable achievements and pleasures. In the process, the reader may discover a previously unfamiliar American artist who both responded to and contributed to a modernist tradition.

While attending graduate school and working as a teaching assistant at Case Western, Ingham began to take design and figure drawing classes at the Cleveland Institute of Art. Despite the satisfying work of assisting Professor Mortimer Kadish compile an aesthetics anthology textbook, the twenty-three-year-old found himself more enthralled with making art than dissecting it intellectually and linguistically.[6] By the end of summer quarter 1968, he intended to return to Seattle but was undecided about the form his future would take. To be an artist, with all its uncertainties, was almost unthinkable, yet it was what he wanted most. And there was always the example of his great-uncle, William Ordway Partridge

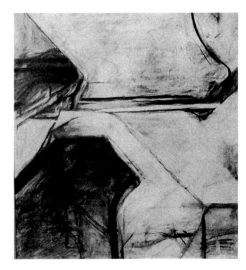

Drawing, 1972, mixed media on paper, 14 x 14

(1861–1930), who had been a prominent Beaux-Arts bronze sculptor in the early 1900s. His statue of President

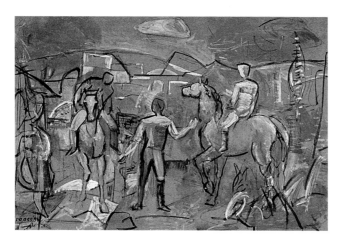

Walter F. Isaacs (1886–1964), *Riders in the Desert*, 1950, oil on board, 47³/₈ x 71¹/₄
Portable Works Collection, Seattle Arts Commission, Gift of the Seattle Teachers Association

Ulysses S. Grant still stands in Grant Park in Brooklyn. Maybe Ingham inherited artistic talent and drive from his mother's side of the family.

Ingham enrolled in the School of Art at the University of Washington as a fifth-year undergraduate student to continue his art studies in earnest and build on the good introduction he had received in Cleveland. Begun in 1919 as the School of Painting, Sculpture, and Design, the art department was highly regarded throughout the western United States. In the thirty-seven years it was led by director Walter F. Isaacs (1886–1964), the School of Art not only assembled a solid studio art training curriculum but attracted capable and, in some cases, prominent teachers from all over the world, including Alexander Archipenko (1938, 1952), Mark Tobey (1941), Swiss potter and secretary to Le Corbusier's Purist group Paul Bonifas (1947–53), Bauhaus designer Johannes Molzahn (1934–44), and prominent Purist painter and theoretician Amédée Ozenfant (1938–39).

During Ingham's years at the university (1969–72), the faculty included figure painters Norman Lundin and Michael Spafford as well as the abstract artist Francis Celentano (b. 1929), a former private student of Philip Guston.⁷ Visiting professor John Thomas encouraged Ingham, as did Kenneth Pawula (b. 1935) and Alden Mason (b. 1919), who at the time was about to drop figural work in favor of poured-paint abstractions.

In 1970 Ingham was accepted into the graduate-school division of painting and began his search for the kind of art that would satisfy him personally and align with his thoughts and beliefs about the nature of art. His master's thesis exhibition in 1972 was strongly indebted to Richard Diebenkorn (1922–1993), a crucially important figure for West Coast art who taught for many years at the University of California, Berkeley. Diebenkorn's example of relying on drawing to divide space in an abstract painting showed Ingham how to control composition while avoiding the extravagant gestures of Abstract Expressionism. William Ivey (1919–1992), a close friend and classmate of Diebenkorn, became another distant beacon. Both Ivey and Diebenkorn had been students of Rothko and Still in San Francisco. Except for teaching one year (1966–67) at Reed College in Portland, Oregon, Ivey spent his entire professional life in a succession of downtown Seattle studios and his final years in a studio behind his home in the city's Interbay neighborhood. While Ingham met the reclusive Ivey only a few times, the older artist's disciplined studio practice appealed to him more than the prospect of teaching. Ingham rented his first studio in the Bay Building on First Avenue near University Street. He soon moved to the Maritime Building a few blocks closer to the water at 911 Western Avenue and

remained there until 1985. The struggle of being an artist, the excitement and frustration as well as the incessant physical and intellectual challenge, lay ahead.

Ingham's move to a downtown studio near Pioneer Square coincided conveniently with the rise of the Seattle contemporary art scene. During the earlier "Tobey years" and the heyday of the Northwest School, also represented by Morris Graves (1910–2001), Kenneth Callahan (1906–1986), Guy Anderson (1906–1998), and Leo Kenney (1925–2001), there were only a few professional galleries. The first were the Woessner Gallery in West Seattle, Zoe Dusanne Gallery on Capitol Hill, Otto Seligman Gallery in the University District, and its successor, Francine Seders Gallery, in the Greenwood–Phinney Ridge neighborhood. With the advent of the historic architectural preservation movement, the landmark Pike Place Market and blocks of the Pioneer Square neighborhood were saved from destruction and urban renewal.[8]

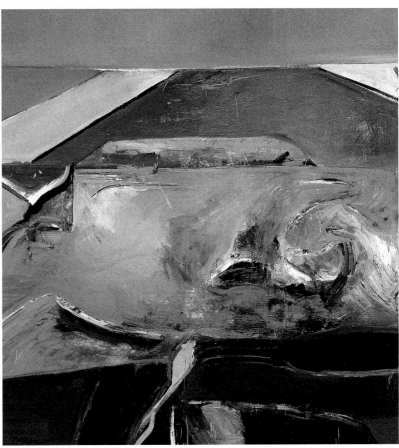

Landscape Open, 1970, oil on canvas, 74 x 68
Collection of Mr. and Mrs. Joseph McKinstry, Seattle

William Ivey (1919–1992), *Untitled*, 1973, oil on canvas, 70 x 94
Collection of Richard and Betty Hedreen, Seattle

Many Pioneer Square buildings were not renovated until nearly twenty-five years later. Until then, low rents ruled the day, and the first three galleries that Ingham became associated with were all in that quarter, rebuilt after the 1889 Great Fire. Brick and stone facades intermingled with cast-iron structures, and ample street-level storefronts and accessible lofts accommodated high-ceilinged galleries. Ingham debuted in a group show held in 1973 at Polly Friedlander Gallery at 89 Yesler Way. The paintings he exhibited were a swift departure from the

Diebenkorn- and Francis Bacon–derived works done from 1970 to 1972. Instead, he built on the best of his grad-school paintings, *With Alizarin* (1972), a 7-foot-high, nearly square canvas of red, pink, and blue passages. Ingham later described *With Alizarin* as an oblique remembrance of a 1969 trip to Spain. He recalled "the profound impression...of Spanish art, mainly El Greco and Goya."

> Trowelling cad reds, alizarin crimsons and umbers across the canvas was both a masking and unmasking, a revealing and a burying, a process of discovery, as I built up and tore down. Originally, the painting contained a figure, but I buried it under paint.... As I worked on *With Alizarin*, all came together. Emotion drove me on and took me to new heights....
>
> A big black diagonal slash in from the left, only to be buried in a reddish, turbulent mass of paint. Then, in a large area of thalo blue, black re-emerges as a gentle piano curve. It sits by itself. I liked the ambiguity of it. Was it a key to something? *With Alizarin* was a culmination, a summation.[9]

Although *With Alizarin* was a culmination of graduate school, perhaps, it proved much more prophetic and open-ended than summational in significance. The canvas was Ingham's first fully abstract painting and, as such, is worth examining for signs of his mature style to come.

First, there is the sense of the movement of the brush across the canvas surface, what would become a central signature mark. Next is the large-scale vertical, but nearly square, format, which he favored for many years. At this height and size, Ingham could approximate Rothko's environmental, wrap-around canvas size; all the better to create a "drama" wherein the forms could be the "characters." Finally, there is the curious palette of red, pink, and blue, with black and white. These, too, would become important colors: primary hues and their variants that resisted immediate decorative analogies.

Other Ingham works from the Polly Friedlander show and another group show, at Dootson/Calderhead Gallery at 311 Occidental Avenue South (the successor to collector Virginia Bloedel Wright's Current Editions), include *Tango* (1973) and several large untitled works ranging from 6 to 8 feet high.

Tango dissolves any trace of a figure once and for all. Tangible influences might be the paintings of Sam Francis (1923–1994), whose first show was at Zoe Dusanne Gallery in 1954, with their visible drips and trailings at the edge, lots of white and blue. Another influence could be Helen Frankenthaler, who was indebted to the poured and dripped technique of Jackson Pollock (1912–1956). Frankenthaler was introduced to Pollock by the critic Clement Greenberg (1904–1994). Both Francis and Frankenthaler became peripherally associated with the Color Field painting movement.

Despite *Tango*'s pours, Ingham never again rejected the brush and, in *Tango* and other paintings from the Polly Friedlander and Dootson/Calderhead era, the gestural manipulation of forms by brushwork is evident. *Tango* is one of Ingham's first paintings to contain an extensive uninflected area of solid color, blue. Leaving the visible activity of correction and overpainting apparent only at the edges, Ingham also echoed the art of other Greenberg protégés Jules Olitski and Larry Poons (both represented

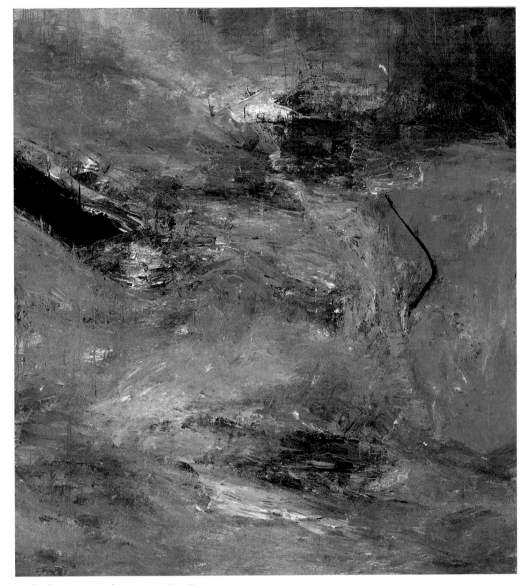

With Alizarin, 1972, oil on canvas, 87 x 80

in the collection of Virginia and Bagley Wright, which Ingham saw at the time).

Taking advantage of the abundant natural daylight that streamed into his studio just one block from Elliott Bay on Puget Sound, Ingham produced the first of his abstract paintings to stand as a singular and distinct body of work within his oeuvre. With bands of pale yellows, pinks, and whites dominating individual paintings, they appear monochrome at first, but as the daylight falls across them, many other colors and rich nuances are revealed.

Ivey's studio was a few blocks away in the Collins Building, where Frank Okada (1916–2000) and other abstract artists also worked, and Ingham unknowingly shared with them a latent luminism also being investigated at this time by the painters Joseph Goldberg (b. 1947) and Paul Heald (b. 1936).[10] It was not an area that would pre-occupy the twenty-nine-year-old for long, however.

Robert Dootson and William Calderhead were both enthusiastic about what they considered Ingham's New York–style abstract canvases. They showed (and sold) several alongside the remnants of Virginia Wright's print inventory, which they had purchased with Current Editions. As Dootson wrote Ingham in 1976:

> Really enjoyed the chance to look at your new paintings. We all agree that they are very strong and could hold their own anywhere.
>
> If and when you decide that you want to sell them, let me know. [Collector and property developer] Dick Hedreen would very much like to buy the last one you showed us (I think you said it was the largest). I would very much like

to buy the second one with the mustard colors in it [*Untitled*, 1976].

> I will give you a call during the week of the 20th when I am home."

Unfortunately, Dootson/Calderhead Gallery closed in 1977 after only one year in business as the economy took a downturn. The Foster/White Gallery (originally the Richard White Gallery), an upstairs art space at the same Occidental address, gave Ingham his first one-man exhibit in September 1978. Donald I. Foster and William Ingham were a good match, and their relationship continued fruitfully until 1984. Foster, a former executive at Frederick & Nelson depart-ment store, had extensive social connections to Seattle's old-guard establish-ment (then the core of the city's small collector base) and professional ties to the interior design elite (soon to become Seattle's ruling tastemakers for affluent younger collectors).

Ingham made tremen-dous strides as an artist with Foster's encouragement and brisk sales. Ingham had mar-ried Ruth Loker in 1966 and by 1974 had two children,

Jules Olitski (b. 1922), *Thigh Smoke*, 1966, acrylic on canvas, 167 x 92^1/$_2$ Virginia and Bagley Wright collection, Seattle
© Jules Olitski/Licensed by VAGA, New York, NY

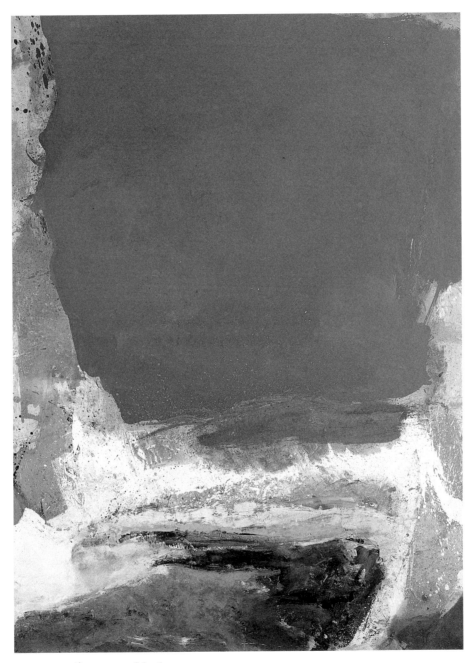

Tango, 1973, oil on canvas, 86 x 63
Collection of Laura Ingham, Seattle

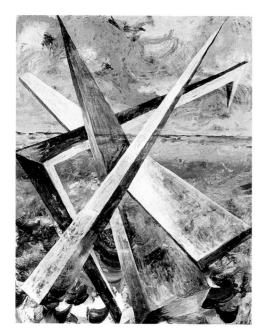

Kenneth Callahan (1905–1986), *Beach Image*, ca. 1979, acrylic or tempera on board or wood panel, 38¹/₂ x 30¹/₂

Collection of Richard and Deanne Rubinstein

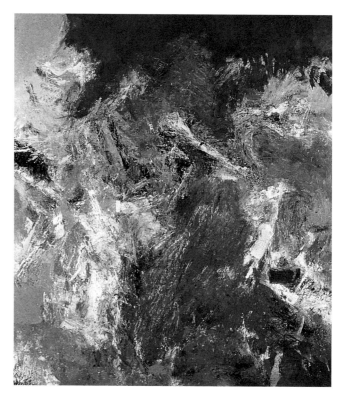

Blue and Ochre, 1978, oil on canvas, 82 x 75

David and Fred. His commercial success was more than comforting; it gave him the grounding needed to continue painting full-time and confirmed the wisdom of his decision not to teach art.

At first, it was not clear how Ingham would fit into a stable that was the bastion of the Northwest School. Besides secondary market resales of works by Tobey and Graves, Foster made possible a successful late-period flourishing for Kenneth Callahan, whose moody multiple-figure groups of the 1940s and 1950s gave way to large-scale, highly gestural red, yellow, and blue canvases inspired by wind and wave patterns.[12] Rather than changing to fit into an increasingly constricting and dated Northwest School, Ingham benefited from Callahan's evolution into a style akin to the New York School (whose members were closer to Callahan in age), yet with definite identifiable traces of water, daylight, and wind.

The best of Ingham's Foster/White-period paintings (exhibited in 1978, 1980, 1982, and 1984) are among the finest he ever painted. They mark the beginning of his mature period, an expansion of his palette to embrace color more fully, and an extension of his mark-making, if not form-making, abilities. In *Blue and Ochre* and *Composition in White with Black Line* (both 1978), Ingham incorporates a great deal of white paint, perhaps as an oblique tribute to the paintings of Mark Tobey that were constantly on view at Foster/White, but without any of the older artist's precious "mystic" intimacy. Instead, white in Ingham's work seems embattled, competing with close-range colors of tan, gray, and pale pink. White plays an equal part, rather than dominating as the carrier of line as it had in Tobey's "white writing." Brushwork, not Asian calligraphy, typifies Ingham's marks in these paintings. Their often turbulent surfaces could conceivably be thought of as waves rushing in and out of a coastal tide pool. Related works like *Blue*

Exterior (1978) and *Convergence* (1979) reinforced the potential allusions to water and beach as well as extended the artist's treatment of the color blue begun in *Tango*.

As the artist grew and became increasingly adept at constructing compositions that were animated and harmonious on a large scale (averaging 5 to 8 feet high), he embarked on a series of smaller works on paper that contain some of his most adventurous explorations of the same elements. The numbered *Abstractions* of 1983 and 1984 are chiefly rectangular, a code shape for landscape, but resist any literal landscape references. Flurries of white interact with a somewhat wider palette and often contain a mixture of horizontal and diagonal strokes. These works hold the germ of the artist's breakthrough larger paintings of 1982–87. About 2 or 3 feet in height and width, they are the closest Ingham ever comes to meeting Tobey on his own ground, a comparably intimate format. He would not directly address Tobey's "white writing" until the larger paintings of the early 1990s.

Ingham was carving out a painterly territory that gradually attracted attention beyond collectors, developers, and interior designers. He was included in group exhibitions, including *Northwest Selections II* at the Seattle Art Museum Modern Art Pavilion and others at the Bellevue Art Museum and the Henry Art Gallery of the University of Washington. As the art world entered a period of renewed pluralism and tolerance for diversity of styles, Ingham's debt to Abstract Expressionism seemed to matter less. After all, if one style no longer dominated American art, what difference did it make if artists were building on (or even satirizing) prior movements?

It began to look as if Ingham was making his own additions to American gestural abstraction. Just as Ivey

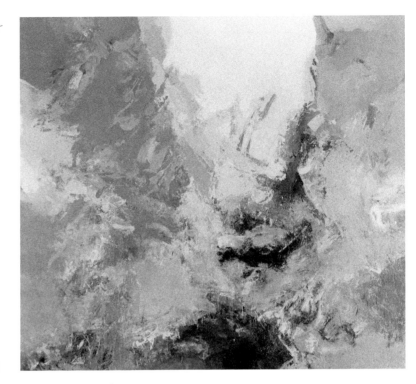

Convergence, 1979, oil on canvas, 74 x 80
Collection of Richard and Betty Hedreen, Seattle

resented being called a "second-generation Abstract Expressionist" along with his ex-classmate Diebenkorn, so Ingham often tired of such associations. As he wrote in 2001:

> Abstract Expressionism was on the decline [in the 1970s], its huge emotional import now seen as verbose, exaggerated and empty.... It didn't matter to me...the 1970s attacked all orthodoxy not just the Abstract Expressionists. Right or not, a painting style takes years to develop. The AE painters rhymed with my inner self in a deep way. Their work was salubrious. It pointed the way. It *was* the way.[13]

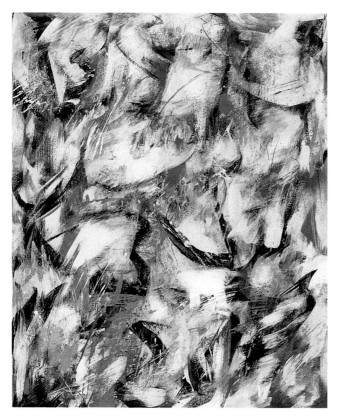

Sea Pines, 1987, acrylic on paper, 30 x 22
Collection of Dr. R. Wendt

Ingham resumed exploring the infinite possibilities of abstract painting. Indulging his obsession with the color blue, *Adobe* and *Immanent Blue* (both 1982) present a newly confident artist, at home with varied gestures teamed with limited color. In lieu of any identifiable central image, color, gesture, and form have to carry everything from composition to optical impact. Of the two, *Immanent Blue* (acquired by the Bellevue Art Museum and transferred in 1999 to the Tacoma Art Museum) defined the stricter set of limits. Commanding a nearly square, roughly 6-by-7-foot canvas, long, aggressive, vertical strokes in varying shades of blue flutter above a barely perceptible central reddish core.

Adobe addresses the same issue—how to make a centerless composition with a narrow palette—but attenuates the height into a vertical format, broadening the strokes considerably. Darker sections hover around central stabs of blue and pink. No one area of the painting is more important than any other. Put another way, Ingham achieves the crucial test of a centerless or "all-over" composition: every part of the painting must be just as interesting and compelling to look at as any other area. Painted when the artist was thirty-eight, after more than a full decade in the studio, *Adobe* is Ingham's first masterpiece.

Erelon (1983), *Untitled* (1984), and *Sephora* (1985) complete Ingham's Foster/White period. They further consolidate the mixture of tentative and determined brushstrokes

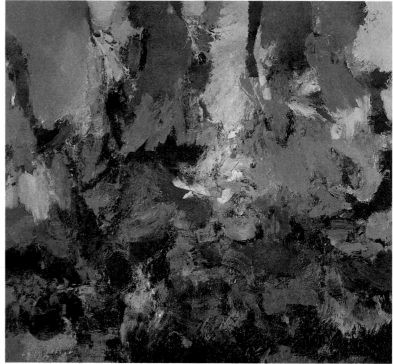

Immanent Blue, 1982, oil on canvas, 76 x 84
Transfer gift of the Bellevue Art Museum, Tacoma Art Museum, 1998.26.32

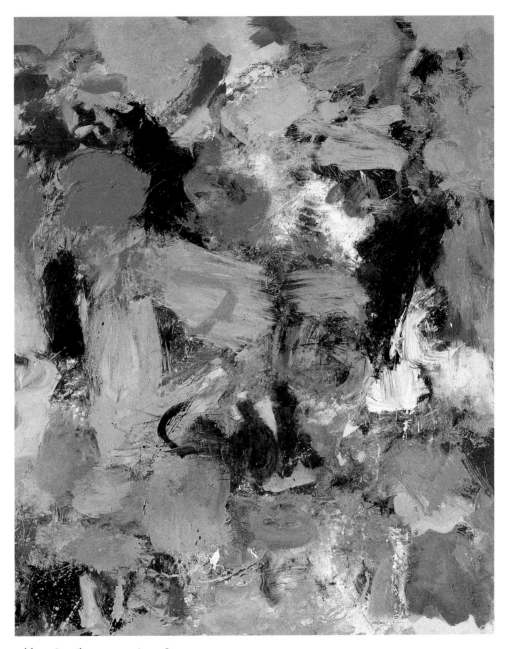

Adobe, 1982, oil on canvas, 60 x 48
Collection of Mr. and Mrs. Douglas Norberg, Seattle

with an expanding palette that sits upon a darker ground. This somber underpainting further separates Ingham from Ivey (who was almost more an "abstract impressionist," to use H. H. Arnason's term for the second-wave New York School) and from de Kooning, whose move to eastern Long Island in 1960 pushed his work closer to natural or light-filled landscape references. For Ingham, the painting must always retain a frankness of circumstance and be openly constructed in a studio, never *en plein air* or filled with recognizable references. As he commented in an interview:

> The painting is not a recipe. The shapes are generated out of the painting process, out of the active working of the surface. When successful, the shapes expand and multiply out in intuitive leaps, yet they seem combined in a deeper way, so that they return to a harmonious balance.[14]

Responding to the evident seriousness in such otherwise exuberant and animated pictures, *Seattle Post-Intelligencer* art critic R. M. Campbell noted early in Ingham's career the "real inward sense. The intense activity on the surface of the canvas is directed toward some undisclosed sources beneath the layers of color."[15] "Undisclosed" is particularly apt since the power of fully abstract art lies partly in its refusal to lay bare its sources in the visible world or elsewhere. A painting exists as an object in the real world, yet for abstract artists it need not be a window onto that world. This resistance to or escape from that world with all its myriad detail—what E. M. Forster called the "world of telegrams and anger"—is abstract art's chief asset and

its target point of criticism for those who insist that art play a more literal social role.

Throughout the 1980s and 1990s, the art world—even in remote Seattle—toyed with art's social responsibility and tasks for implementing social change. Ingham, like Ivey, remained aloof and stayed the course of abstraction, preferring its "undisclosed sources" and the pursuit of beauty for its own sake. His paintings are talismans of the inner life, the encounters between paint and canvas that may be fraught with their own crises and failures. Comparing the act of painting to mountain climbing, Ingham conceded, "When paintings fall short or below their content, there can be real difficulties."[16] Nevertheless, the artist proceeds, committed to the creative act and to the conviction that an abstract painting can communicate

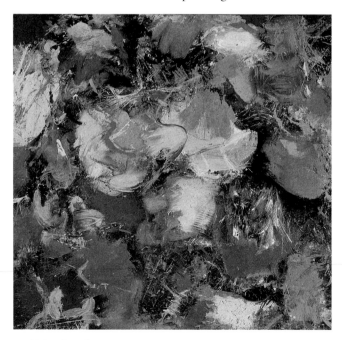

Untitled, 1984, oil on canvas, 45 x 47
Collection of Mr. and Mrs. Peter Hanson, Seattle

with the viewer. Indeed, as Arnheim held, "It must not be forgotten that the observer himself acts as a frame of reference."[17] Thus, it is not only sculpture that requires the human body to complete its experience; Ingham's paintings envelop the viewer and call upon him or her to respond to the litany of marks, gestures, colors, and emerging and receding forms.

Thus, for Arnheim, as for Ingham, the construction of meaning for the abstract painting is a partnership with the viewer, a fragile and trusting relationship contingent upon the viewer's willingness to go along for the ride. So long as an art audience exists that is willing to do so and take the risk of uncertainty, the viewers of abstract art will remain. As this audience diminishes or increases, so does the fate of abstract art waver and hold.

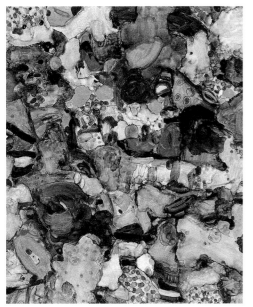

Alden Mason (b. 1919), *Rainbow Flinger*, 1972, acrylic on canvas, 85 x 70
Collection of Mr. and Mrs. Robert M. Sarkis, Seattle

With their revolving shapes, dynamic forms, and quickly rotating motion, Ingham's paintings from 1983 onward may be predominantly *about* motion. While Arnheim wrote, "Motion is the strongest appeal to attention," the challenge for Ingham and other gestural painters is to freeze motion on a flat, inert surface and yet keep it alive. To be sure, unlike kinetic sculpture, motion in painting is an illusion, a record of traces left by the artist, "remnants," as Arnheim put it, "that are present now."

These traces are not identical with the original experiences, because they are continually modified by other traces, imprinted upon the [viewer's] mind.... Everything that came before is constantly modified by what comes later.[18]

Ingham moved in 1985 from the Maritime Building to the Northwest Industrial Buildings at the foot of Denny Way

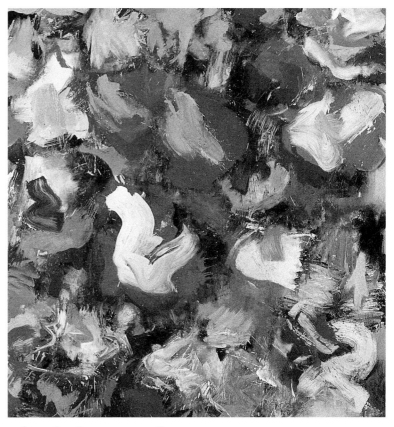

Sephora, 1985, oil on canvas, 71 x 68
Location unknown

(3131 Western Avenue, Studio 503); he not only changed studios but within the year had a new dealer. Although Gordon Woodside was not part of the initial Seattle art establishment, over forty years he has become the region's longest-lasting and most senior art dealer. He began in a small house at 803 East Union Street in 1961; by 1985 he had acquired substantial storefront rental space in a former auto dealership on Howell Street, as well as a new partner, John Braseth. For the gallery's twenty-fifth anniversary show in 1985–86 Woodside contacted Ingham to borrow a painting. The timing was right for Ingham. Although Foster had been supportive in Ingham's forma-

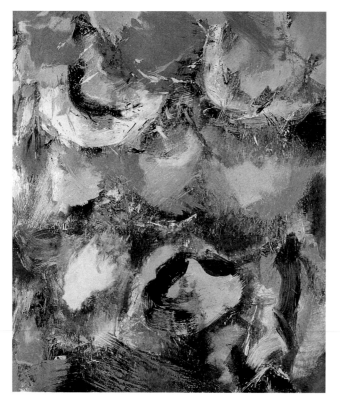

Felicity, 1987, oil on canvas, 70 x 64
Collection of Mr. and Mrs. Gilbert Anderson, Seattle

tive years, Ingham was attracted by the gallery's smaller stable as well as Woodside's commitment to serious abstract painting. Now forty-one, Ingham was considerably younger than the rest of the roster, which included abstract painters Ivey, Carl Morris (1911–1989), Louis Bunce (1907–1983), Celentano, and Kathleen Gemberling Adkison (b. 1920), a former Tobey student living in Spokane.

Within two years Ingham had his first solo show at Gordon Woodside/John Braseth Gallery. The compositions of *Willow* and *Felicity* (both 1987) are freer, less tight, with loosely interacting forms and a great emphasis on circular blobs of color surmounted by light-colored curving brushstrokes. Accentuating what Ingham later called a "centrifugal pivot point," each painting consists of curved forms resembling spinning tops. In *Willow*, blue fills the upper corners and foretells a stricter horizon band in future works but falls short of any natural-world parallel. Fewer and larger strokes, mostly vertical, drag downward and stabilize the picture plane. *Felicity* shares similar colors—blue, pink, yellow—but is more tightly structured, seen especially in the addition of dark brown and black strokes. Here, too, a foretaste of later work may be evinced. Strong light and dark contrasts characterize Ingham's work a decade later, sacrificing, in some cases, closer chromatic relationships, but in *Felicity* and *Willow* the power of colors is reinforced by their proximity to one another.

Such issues continued to be investigated in *Blue Prime* (1988), with its even greater margins of blue, and in another masterwork, *Untitled 2 (China Series)* (1989). Stretching the painting even higher, to 9 feet, the *China Series* may refer obliquely to the artist's trip to China in 1985. The tall

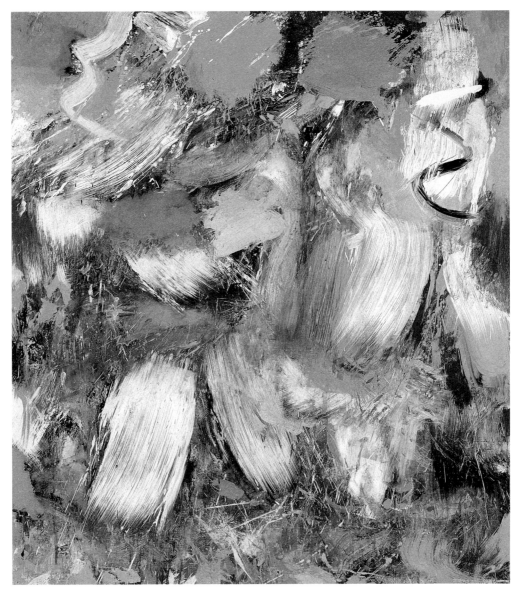

Willow, 1987, oil on canvas, 40 x 36
Collection of George Mack

format immediately recalls the hanging-scroll or vertical–book-page format of classical Chinese brush painting. Here, and in *Untitled 1 (China Series)* (1987), the artist uses his widest palette to date, incorporating orange, olive, maroon, and beige as well as the familiar red, yellow, and blue. *Untitled 2 (China Series)*, one of Ingham's largest works, handles composition as a series of boldly brushed solid-color sections surrounded by smaller strokes and corrected underpainting. In *Untitled 1*, black and white play a greater role both in the division of pictorial space and the overlay of white splotches that cascade diagonally across the tall canvas.

The paintings of these years continued to attract positive attention and led to Ingham's inclusion in several group surveys, at Oregon State University and at the Prichard Gallery of the University of Idaho at Moscow. The second show, *Frontiers of Abstraction*, included prominent West Coast painters and sculptors Peter Voulkos, John Roloff, and Renee Stephens along with fourteen others. *Artweek* critic Ron Glowen commented on how "the canons of mainstream abstraction are anchored by William Ingham's...small swirls of brushwork."[19]

Field, *Heart of Gold*, and *In Memory, David* (all 1992) are other standouts from Ingham's early Woodside period. Ingham held his own identity even as he was perhaps liberated to make bolder strokes by the example of fellow abstract painters he respected, such as former professors Alden Mason and Robert C. Jones and an American expatriate artist originally from Seattle, John-Franklin Koenig.

White is a key color in *Heart of Gold*, but it is the painting's slivers and slices of chrome yellow that activate its surface. Where there is white, black often follows, and in *Heart of Gold* we witness the artist's growing interest in

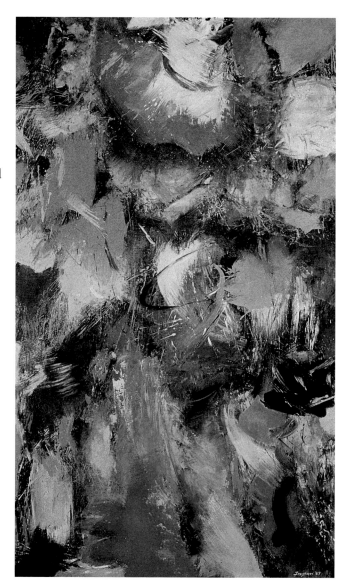

Untitled 1 (China Series), 1987, oil on canvas, 60 x 36
Collection of Henry Dean, Sun Valley, Idaho

such high-contrast, positive-negative color combinations. *Field*'s composition is less subtle: a strong black shape lies dead center in the roughly square, almost 6-by-6-foot canvas. Larger areas of color, chiefly an upper right-hand

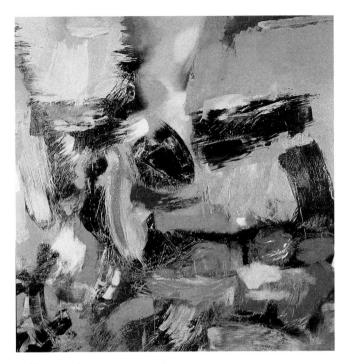

Field, 1992, oil on canvas, 70 x 68
Private collection

assuage such grief. In that sense, *In Memory, David* relates to other elegiac modernist works, such as Robert Motherwell's *Elegies to the Spanish Republic* (1940-85) and *Irish Elegy* (1965). Ingham uses the color white the way Motherwell used the color black. Just as the symbolic mourning for the defeated Spanish Republic required an unusual and generalized image, so it is appropriate that the grieving father would create a commemorative work of art. A painting, unlike a poetic elegy, is nonverbal, and had William Ingham been a composer, his musical tribute would have been nonverbal as well. An abstract painting is nonrepresentational in addition to being nonverbal—all the better perhaps to respond to the overwhelming loss of one's child.

 In Memory, David requires the title to identify it as an elegy, as do Motherwell's paintings for the Spanish

corner of pink, allow for less spatial interplay but offer, in turn, a more anchored composition.

 For *In Memory, David*, the artist created not so much an elegy to his son (who died tragically in a ski accident) as a light-filled tribute. A good example of what the artist once described as "working from the bottom of the painting to the top," this work has strong ascending spaces. The blinding white of the upper corner near a sunlike yellow shaft may evoke the snowy mountain, or it may symbolize release from earthly suffering or even signify heavenly transcendence over death. As the grandson of an Episcopalian bishop, Sidney Partridge of Kansas City, Missouri, Ingham maintained his faith in an afterlife, which may have sustained him at this time. The act of painting carries a potential immortality of its own, though none that could

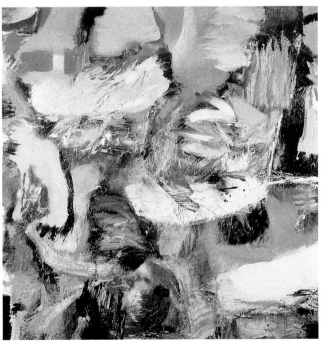

Heart of Gold, 1992, oil on canvas, 71 x 65
Collection of Mr. and Mrs. David Auth, West Palm Beach, Florida

Republic. More than a ceremony of grief, however, Ingham's work may allude to the celebration of release into the divine. Ingham remains reluctant to interpret the painting beyond stating its deep personal importance to him.

Seen in the broader context of modernist painting in the Northwest, *In Memory, David* is an open reply to William Ivey and Mark Tobey, the twin pillars of Seattle modernist painting. Of Ingham's paintings it is the closest to the spiritual subjects of the Northwest School. Although he comes closer to Tobey's use of white to convey religious ecstasy than at any other time, the firm textural presence of his oils prohibits a strict comparison with Tobey's ghostly transparency in tempera. The two artists met in common spiritual transcendence or unearthly interest, though they shared the space only briefly.

Between the time Ingham began painting in 1972 and David's death, the whole position of American abstract painting had changed. Once a place for intellectually serious artists only, it had become simply one more consumer choice for artists inundated with the stylistic choices of pluralism.

Robert Motherwell (1915–1991), *Irish Elegy*, 1965, acrylic on canvas, 54 x 69
Collection of Jane Lang Davis, Medina, Washington
© Dedalus Foundation, Inc./Licensed by VAGA, New York, NY

Mark Tobey (1890–1976), *Tropicalism*, 1948, tempera on paper on board, 27 x 20
Courtesy of Achim Moeller Fine Arts, New York

The purported transition from modern to postmodern art that occurred in the 1980s and 1990s looks in retrospect less like a profound cultural sea change than an expansion of options. German artists such as Gerhard Richter and Sigmar Polke moved freely back and forth between abstraction and representation with no accusations of fickle sensibilities. The battle of abstract art to be taken seriously by the American public had been lost and won and then, seemingly, lost again.

All this put Ingham in a peculiar position. If the artist's commitment to seriousness of purpose remained the same but the audience had changed, how could the abstract artist still be taken seriously? Abstract painting in Seattle and elsewhere frequently took on a satirical or ironic appearance. Gradually, Ingham's paintings assumed the sheen of history in some people's eyes rather than the

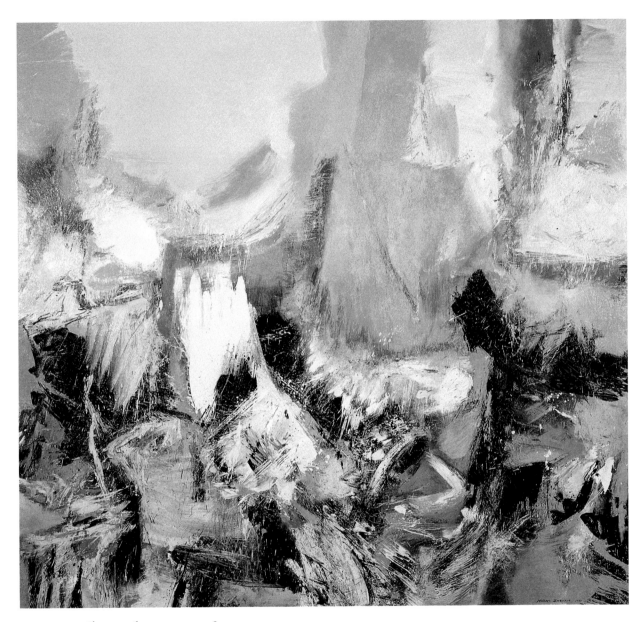

In Memory, David, 1992, oil on canvas, 72 x 80
Swedish Medical Center, Seattle

bright light of the new. Unconcerned about pleasing an indecisive audience, Ingham delved further into his own sensibility by, astonishingly, giving in to the urge to make realistic art in the form of pencil landscape drawings.

Meanwhile, the artist's color sense shifted, surprisingly, toward lighter, near-pastel shades. Light in the guise of the color white played a greater role, not in tribute to Tobey but as a spatial device to divide the canvas space into sections that separated bright solid colors from one another.

Aqua (1993), *Sagadahoc* (1995), and *Nebulous Drama* (1996) present progressively distinct approaches to the question of how to continue painting abstractly in a period of photography and realism. With the advent and primacy of Conceptual Art, painting itself was once again deemed irrelevant or obsolete. Hearteningly, Ingham carried on, in no way running out of ideas or questioning his belief in the superior aesthetic viability of a painting that allowed the viewer an open-ended response.

In *Aqua*, the broad swaths of white (some painted with a 12-inch-wide brush) are lightly applied so that the colors underneath show through. Such layering reveals a shallow and ambiguous space "beneath" the picture plane but steers clear of any deeper perspective. *Sagadahoc* introduces four dominant greenish black columns around which blue and white areas swirl. As white marks feather back in over the black, the darker shapes march across the canvas, even bordering on a vaguely figurative character. The blends of blue at the top and sides further reinforce a maritime analogy. They may be an oblique memory of the Maine coast, which the artist visited periodically to see his wife's family on Penobscot Bay. A graffiti-like twisting line at the picture's center stands as a symbolic sign of motion,

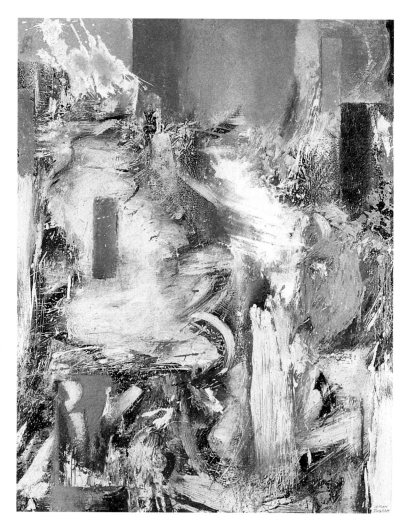

Nebulous Drama, 1996, oil on paper, 37 x 31
Collection of Ms. Pauline Brim

setting the entire composition's movement into a stylized whirl. Ingham is painting at the top of his form here.

Nebulous Drama, a smaller work on paper, introduces a few vertical blocks of solid color over a highly animated ground. Although we can detect an echo of Hans Hofmann (1880–1966), who placed solid slabs of color over less solid grounds, such shapes are more tentative in *Nebulous*

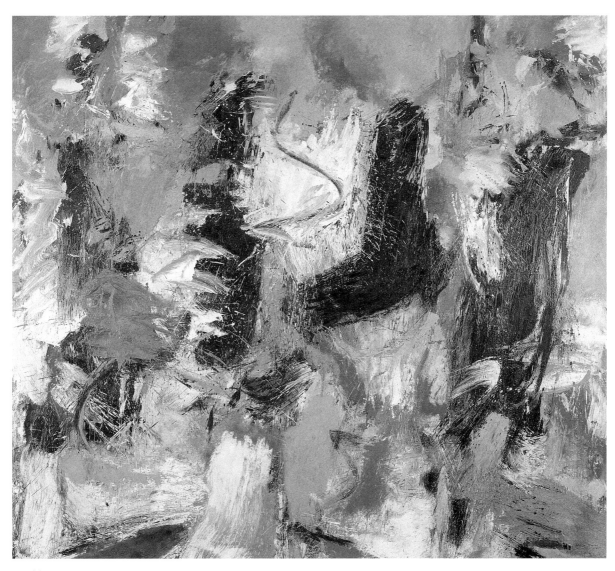

Sagadahoc, 1995, oil on canvas, 74 x 80
Collection of Mrs. Jeannie Pollart, Seattle

Drama, and the strange palette of orange and purple is a departure for the fifty-two-year-old painter.

In the subsequent works *Fonteel 2* and *Atlantic Side* (both 1996) and *Thermopylae* and *Lyric Blue* (both 1998), Ingham adds geometric structures beneath the medley of marks. As structural devices to enhance compositional complexity, they mark a definite shift with a corresponding sacrifice of gestural autonomy. In all four works, the imagery at the painting's base is fragmented and splintered by more solid, reassuring forms rising above in the middle and top sections. *Thermopylae* is among Ingham's most dramatic works. Using his new device of more sharply defined edges, the seeming column of fire, referring to the ancient battle of Thermopylae between the Spartans and Persians in 480 B.C., is tightly held in, locked between curved and angled slabs of black paint. A patch of blue to the right could be interpreted as sky beyond the smoke of fire.

Light above the River (1998) and *Scimitar* (1999) undermine any daylight with their brooding black underpaintings. In the first, water seems to rush toward the picture's base, possibly alluding to an architectural structure in the upper right-hand corner. Ingham is no longer strictly

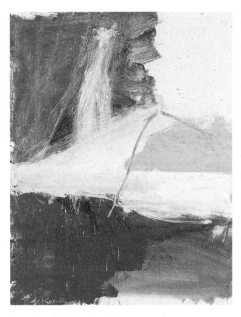

Willem de Kooning (1904–1997), *Wall Landscape*, 1958, oil on canvas, 61¹/₂ x 49
Seattle Art Museum collection, 77.44, Gift of Mr. and Mrs. Bagley Wright, Seattle
© 2002 Willem de Kooning Revocable Trust/Artists Rights Society (ARS), New York

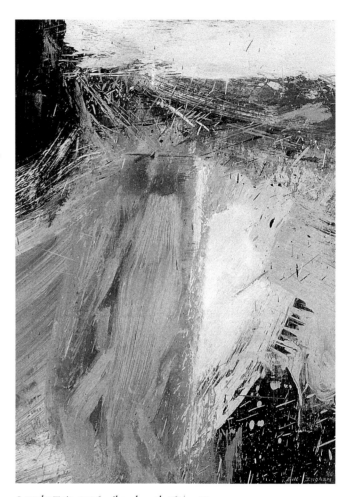

Lavender Twist, 1996, oil on board, 16¹/₂ x 12

abstract in these works, but the oscillating forms and slightly dimensional underspace do not preclude the paintings' focus on a vocabulary of brushmarks.

In *Scimitar*, a bowed gray shape like a sword blade dominates the center, surrounded by an extraordinary range of marks, dots, spatters, and smears. Ingham's command over painterly effects is supremely secure, devoid of the slight doubt and uncertainty that defined his earlier work. Spattering and fracturing of the paint swath become

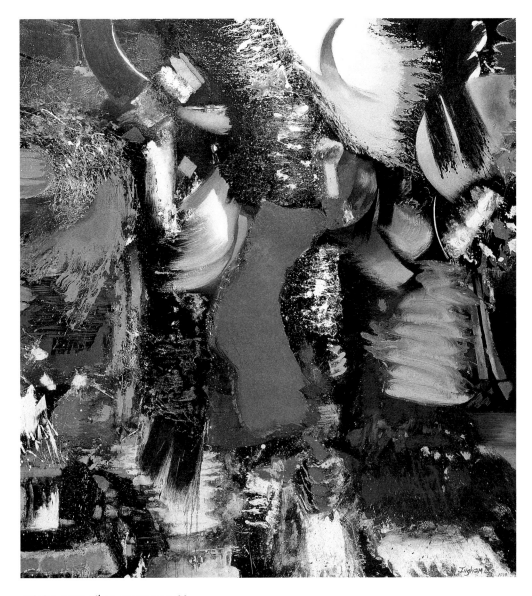

Scimitar, 1999, oil on canvas, 72 x 66

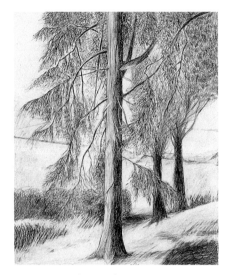

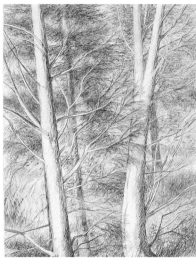

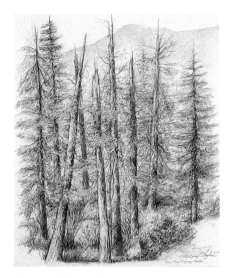

Cedar Tree, Madrona Park, 2000, graphite on paper, 16 x 14

Two Cedars, Arboretum, 2001, graphite on paper, 22¹/₂ x 17

Trees near Skagway, Alaska, 2000, graphite on paper, 16 x 14

more important in works of this period, all leading toward an astounding development—the artist's return in 1999 and 2000 to realistic landscape drawing.

The landscapes, begun after a trip to Alaska in 1999, span geographic locales including the Seattle neighborhoods of Madrona Beach, Leschi Park, Viretta Park, and the University of Washington Arboretum as well as more distant spots such as Whidbey Island, Washington, the Oregon Coast, Skagway, Alaska, the Coastal Ranges, and various glaciers. Together they constitute a parallel but formerly hidden plateau to Ingham's paintings, some drawn on-site, some recollected in composite form later in the privacy of Studio 503 (and, after 2001, Studio 505).

Looked at more closely, the drawings have a documentary as well as artistic character. They depict landscaped areas in Seattle city parks (man-made nature, so to speak), untouched old-growth timber in Alaska and Oregon, and clear-cut land in Washington State. More than just the idea of the tree, Ingham's drawings capture the fate of the tree in the Pacific Northwest and, by extension, the fate of nature in a postindustrial period of population expansion, shifting ecological consciousness, and renewed appreciation of threatened wildlife habitat.

Ingham's tree drawings are carefully composed, far from snapshot reminiscences. Their formal properties, with strong intersecting vertical and horizontal lines of trunks and branches, echo in some ways the splaying of marks in his paintings. Obviously, line plays a greater role here than in the paintings, where it is carried by the brushstroke and defined by its thickness and direction. As Ingham commented about the drawings:

I was drawn to these trees' dramatic patterns of branches and light and dark, which I wanted to emphasize, but not at the expense of a faithful or accurate rendering.... [Former U.W. professor] Jacob Lawrence had talked about "getting out of the studio" to refresh our

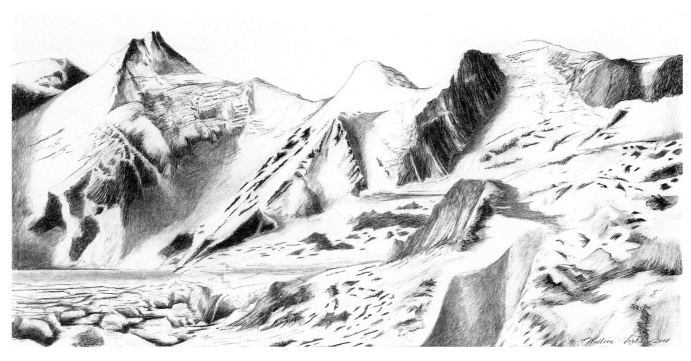

Alaska Glacier, 2000, graphite and colored pencils on paper, 20 x 32

approach, our vocabulary, as painters, which was understandable, especially in that my own work echoed natural forms.... Taking my art to these places *reversed* the artist/studio relationship. Inside the studio, I could dominate the canvas... but outside, with sketch pad and pencil, I was humbled by these huge trees, their size and manifold shapes. They dominated me. Like 19th-c. artists Moran and Cole, I simply wanted to render these huge trees for their own sake, forgetting it was art but forcing myself to render their intriguing patterns.... The drawings became a kind of foil to the painting which relied on such a raw physical approach. The drawings deal with things three dimensional, not just paint on a flat surface.[20]

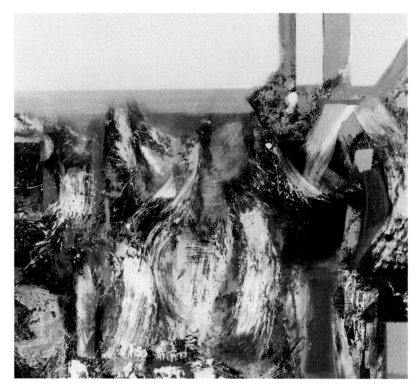

Purple Noon, 2000, oil on canvas, 67 x 70

Before, during, and after the pencil drawings, Ingham's fin de siècle paintings present increasing signs of solid–color geometric passages side by side with stronger landscape associations. He seemingly was more connected to the natural world after his Alaska cruise and repeated forays into city, county, state, and national parks, and these paintings often contain an upper blue band that can only be described as a glimpse of sky. Titles like *Purple Noon* (2000) and *Hints of Landscape* (2001) reinforce such an interpretation. Furthermore, two vertical stripes across the horizon line in *Purple Noon* could form a partial window frame. And in *Hints of Landscape*, a single white line divides the painting nearly in half, descending midway from the top. Landscape may be hinted at here, but it is an uncertain locale dependent upon the manipulation of paint and brush. Colors are scattered in spots and flecks rather than solid or blended sequences.

Gates of Fire (2001) is even more strictly divided; solid-color sections seep in at the top and sides, setting off more gestural areas with a strong sense of divided space. An irregular yellow polygon seems just beneath the picture's surface, as outer yellow edges emerge from a covering of white strokes.

Ingham is onto something very different here: the juxtaposition of hard-edge areas with more randomly brushed sections. In *Gates of Fire* and the tall, narrow *Ascending* (2001), images from one century join those of

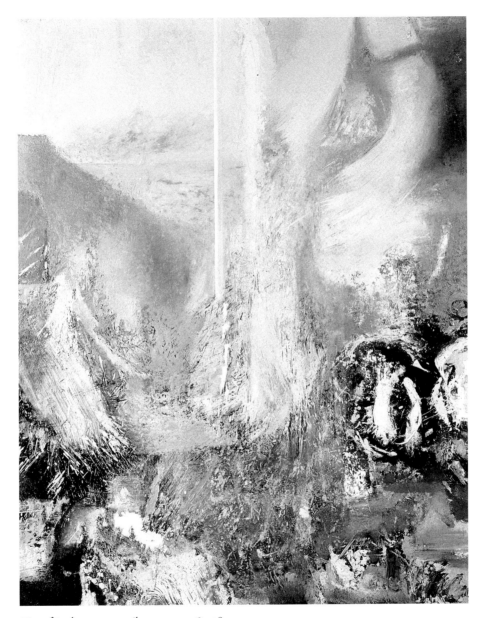

Hints of Landscape, 2001, oil on canvas, 36 x 28

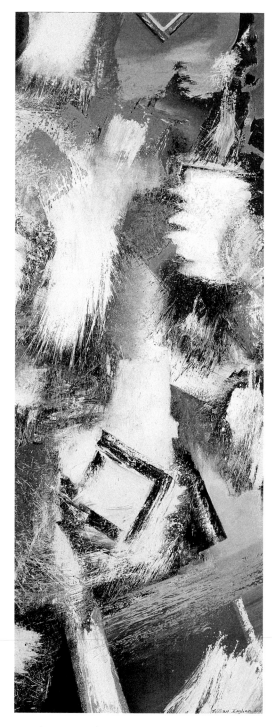

Ascending, 2001, oil on canvas, 75 x 28

William Ingham, Studio 505, Northwest Industrial Buildings, Seattle, February 2002

another; the spontaneous strokes of Abstract Expressionism are combined with squares and triangles of order and control. Plan now participates more openly with impulse, and on an equal footing. Inserted structures shove the abstract painting closer to where pictorial space supersedes flatness. Could it be that Ingham is abandoning abstraction for the representationalism of the tree drawings?

Such a shift seems unlikely for an artist in supreme command of the tools of abstract painting. We have seen how Ingham's art emerged after the end of one art movement, Abstract Expressionism, and extended past the time when a defense of gestural painting was a required passport for intellectual legitimacy and relevancy. Two decades later, far from being a defense, abstract art has taken its place in the plethora of menu items which younger artists choose from, unaware of the cultural battles mid-twentieth-century artists fought for its acceptance and recognition.

For artists of Ingham's generation, to not depict the visible world literally was a high calling, almost a spiritual pursuit. With the passage of time and the tremendous changes the art world has seen, those artists who remained committed, as did Ingham, have a considerable body of work to show for the decisions they made long ago.

We have seen the birth, youth, adolescence, maturity, and mastery of one artist's paintings and the environment in which they arose—not at the center of things, but several steps removed in time and place—which grants them a splendid, uninterrupted isolation of their own. Not even the artist knows where the paintings will lead him, but it surely will be into a new realm that contains comparable surprises and pleasures. As they stand, Ingham's paintings retain a remarkable freshness and satisfaction that will endure as long as people care to look at art that reveals itself gradually over time. That is the irony of William Ingham—such motion in paint, such a configuration of forces, must remain in the stable, sustained viewing context necessary for appreciation and enjoyment.

NOTES

1 William Ingham, "Signs of the Times: UW Graduate Studies 1968–1972," unpublished manuscript.

2 Maurice Merleau-Ponty, "Eye and Mind," in *Aesthetics*, ed. Harold Osborne (London: Oxford University Press, 1972), pp. 55–85.

3 Rudolf Arnheim, *Visual Thinking* (Berkeley: University of California Press, 1969) and *Art and Visual Perception: A Psychology of the Creative Eye* (Berkeley: University of California Press, 1967).

4 Harold Rosenberg, "The American Action Painters," in *Tradition of the New* (London: Paladin, 1970), pp. 35–47.

5 Mark Rothko, "The Romantics Were Prompted," in *Possibilities I*, ed. Robert Motherwell et al. (New York: Wittenborn, Schultz, 1947), p. 84.

6 Mortimer Kadish, ed., *Reason and Controversy in the Arts* (Cleveland: Case Western Reserve University Press, 1968).

7 Celentano is the author of "The Origins and Development of Abstract Expressionism in the United States," master's thesis, New York University, 1957.

8 The movement was represented chiefly by two citizens groups, Allied Arts and Friends of the Market.

9 Ingham, "Signs of the Times."

10 See Matthew Kangas, "Paul Heald and Late Luminism," in *Paul Heald: Selected Works 1960–1981* (Bellevue, Wash.: Bellevue Art Museum, 1982).

11 Robert Dootson, undated letter to William Ingham.

12 See interview with Kenneth Callahan by Matthew Kangas, *Argus*, January 4, 1980.

13 Ingham, "Signs of the Times."

14 Interview with author, December 17, 2001.

15 R. M. Campbell, "The Charm of Calder...Ingham," *Seattle Post-Intelligencer*, September 20, 1978.

16 Interview, December 17, 2001.

17 Arnheim, *Art and Visual Perception*, pp. 367, 360.

18 Ibid., pp. 360, 363.

19 Ron Glowen, "Abstract Images and Objects," *Artweek*, October 30, 1987.

20 William Ingham, artist statement, January 9, 2002.

PLATES

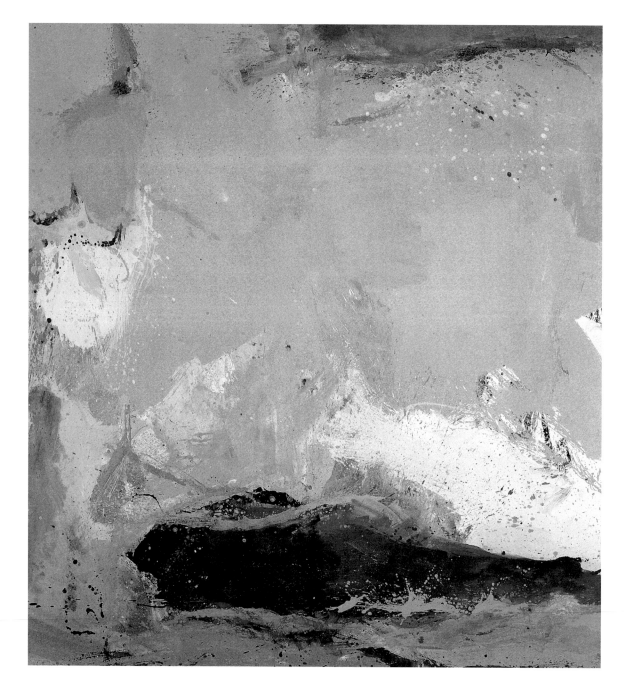

Untitled, 1974, oil on canvas, 72 x 67
Collection of Mr. and Mrs. Steven Clifford, Seattle

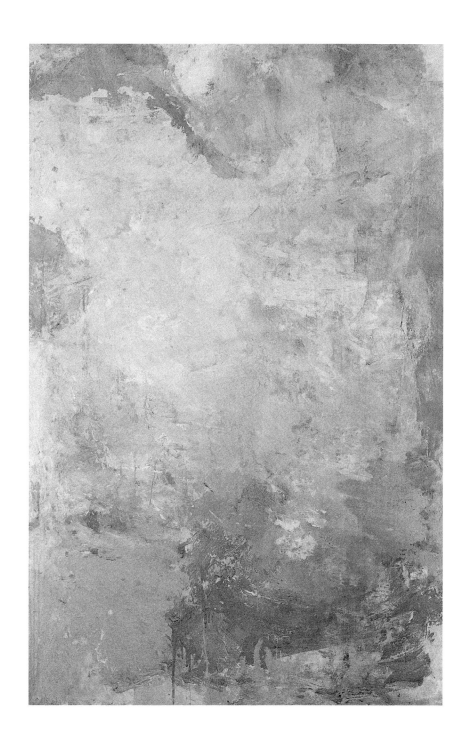

Glissade, 1974, oil on canvas, 89 x 50
The Alhadeff Family collection, Seattle

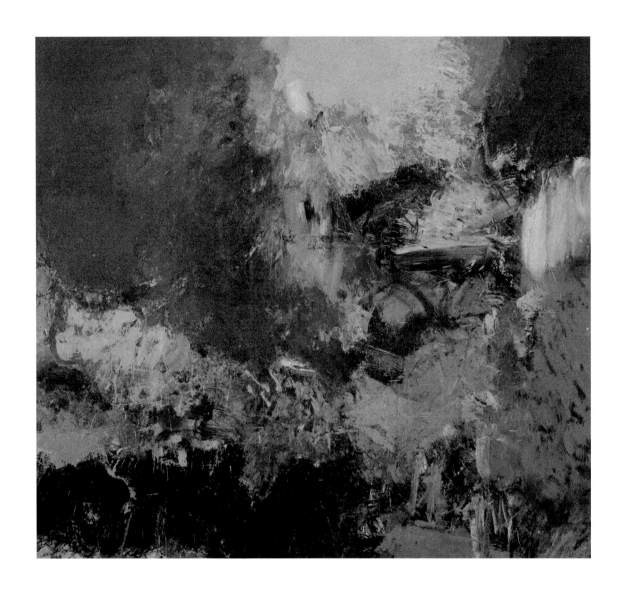

Emergence, 1982, oil on canvas, 74 x 80
Collection of Orbanco, a subsidiary of Security Pacific Corporation, Portland, Oregon

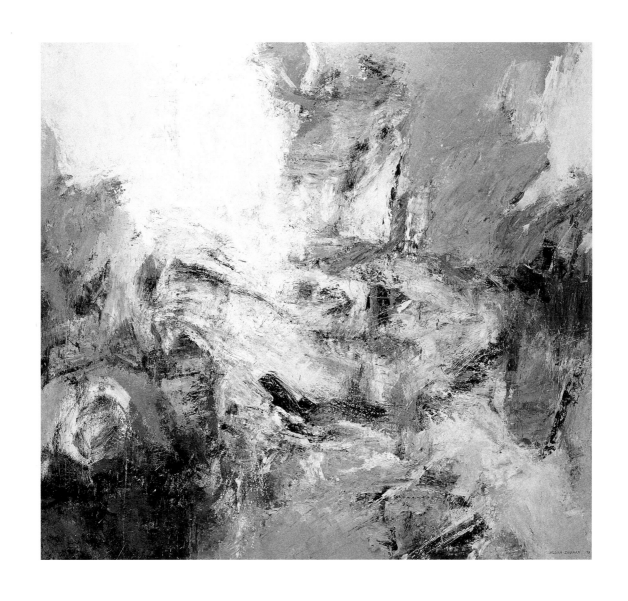

Composition in White with Black Line, 1978, oil on canvas, 75 x 83
Collection of Mr. and Mrs. Brooks Hawkes, Seattle

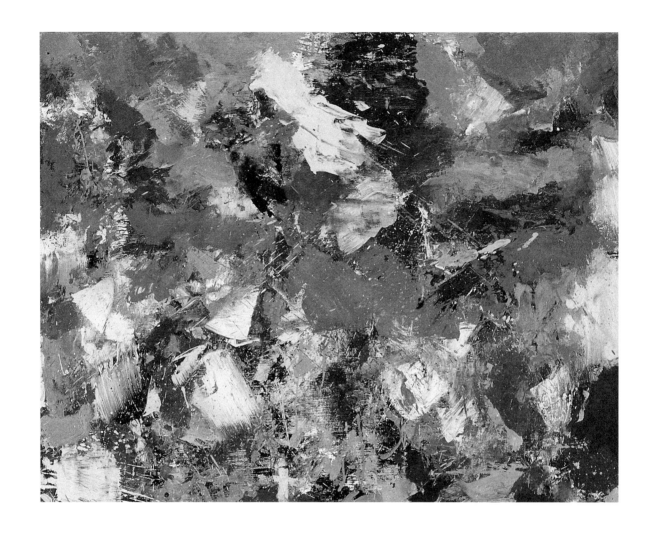

Autumn, 1981, oil on board, 22 x 28
Collection of Bernice Loker, Rockland, Maine

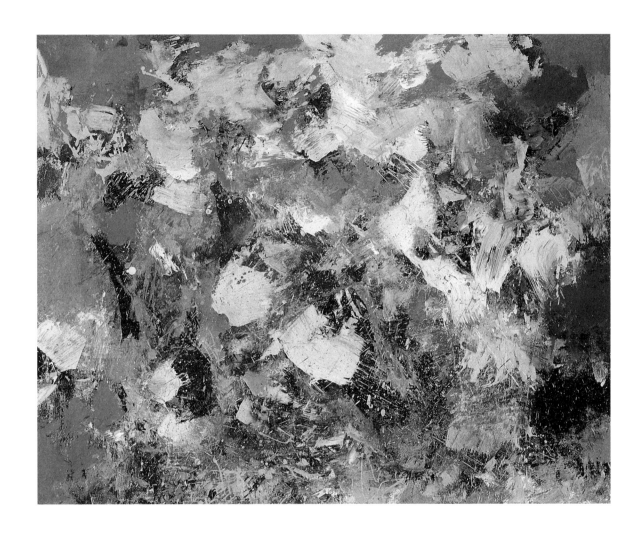

Abstraction 1, 1982, oil on board, 24 x 30
Collection of Mr. and Mrs. Robert Davidson, Seattle

Viridian, 1984, oil on board, 30 x 40
Collection of Accordia Northwest, Seattle

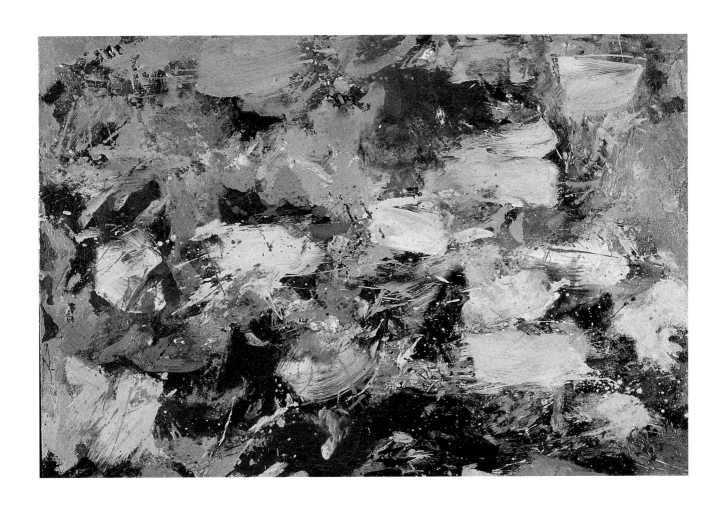

Erelon, 1983, oil on canvas, 72 x 60¹/₂
Collection of Fred Donadel, Seattle

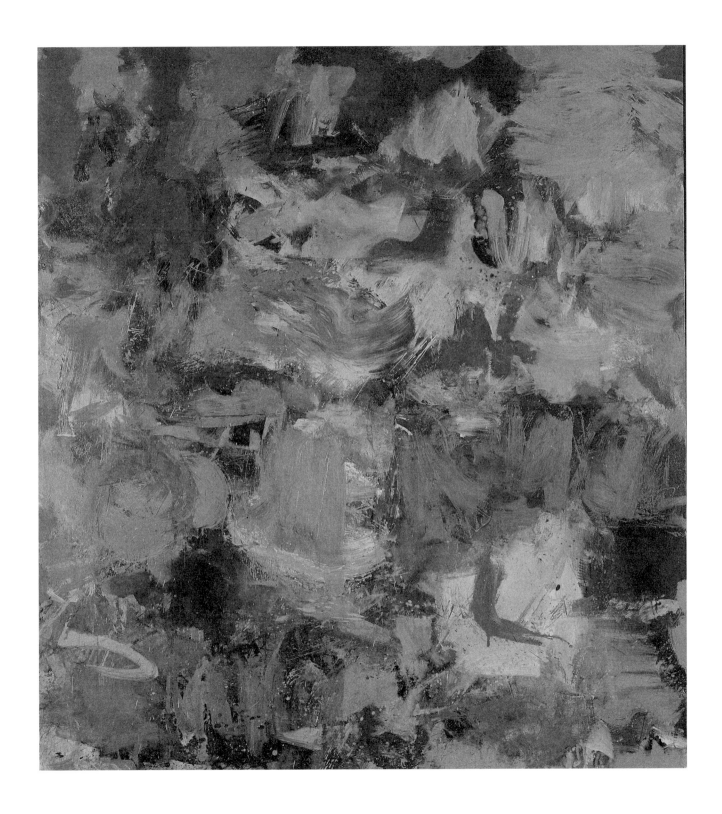

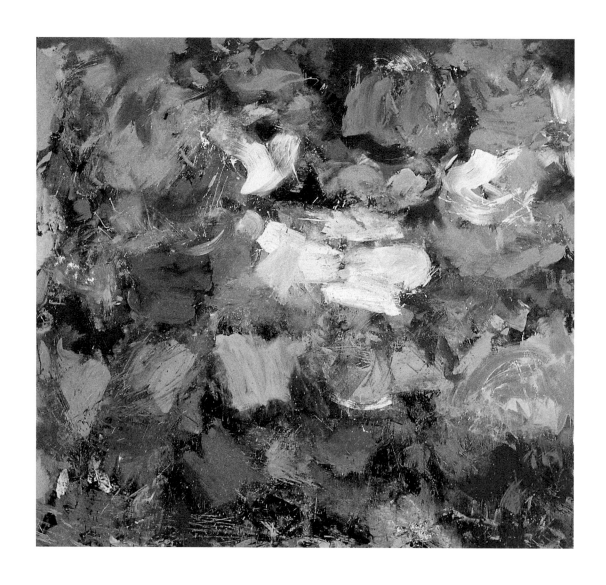

Au Clair, 1984, oil on canvas, 69 x 75
Private collection, Los Angeles

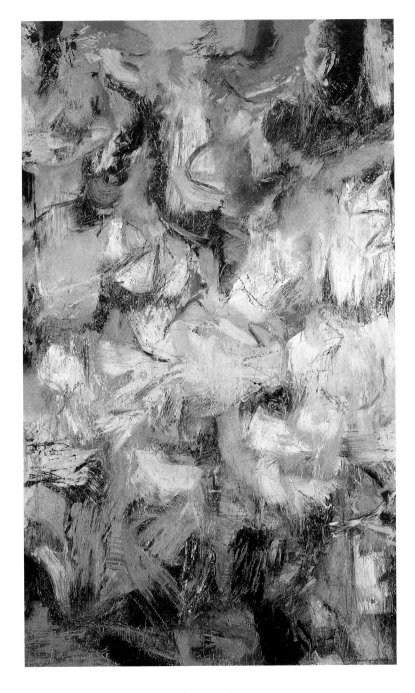

Untitled 2 (China Series), 1989, oil on canvas, 144 x 72
Collection of Mr. & Mrs. Herbert Schwartz, Medina, Washington

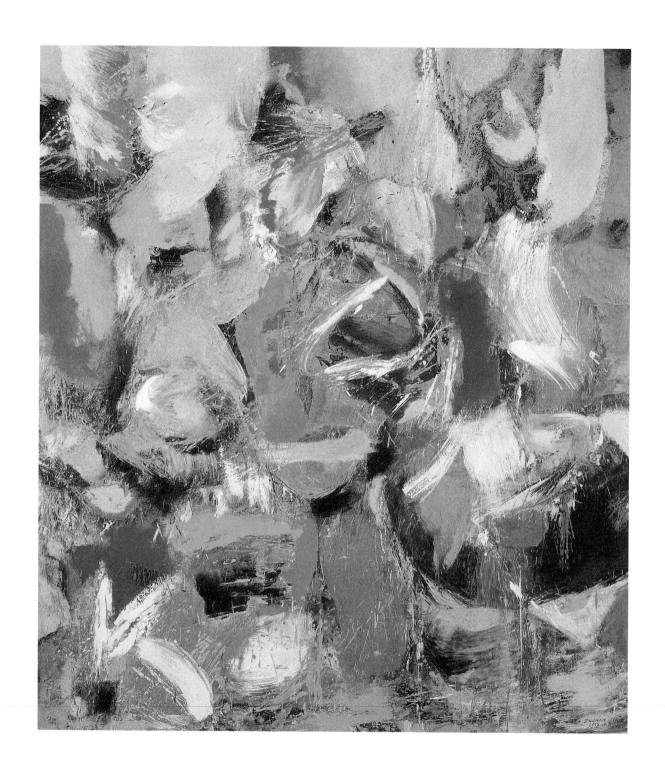

Blue Rondo, 1987, oil on canvas, 40 x 30
Collection of Firstar Corporation, Minneapolis, Minnesota

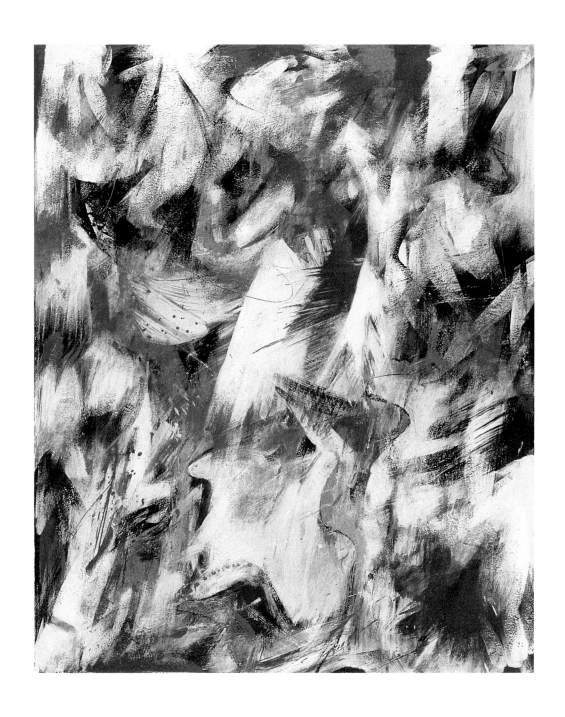

Edge of the Forest, 1987, oil on board, 14 x 10
Ferguson & Burdell, Bellevue, Washington

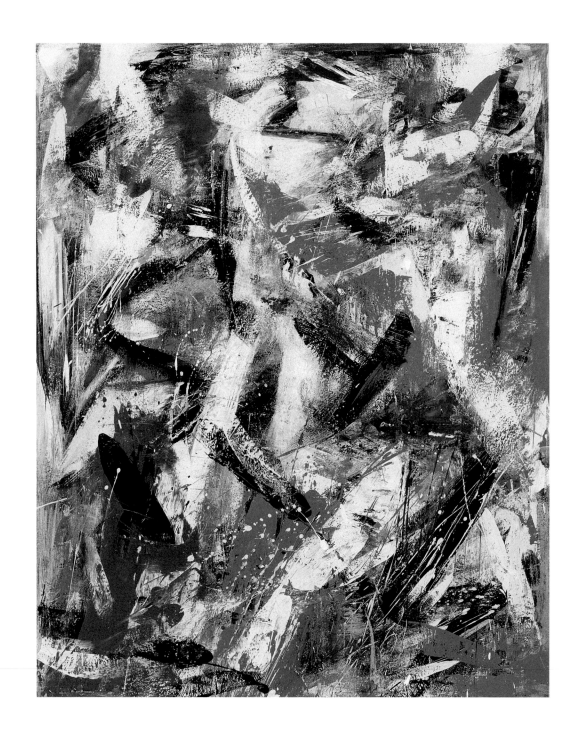

Dutch Treat, 1988, oil on board, 22 x 18
Collection of Mr. and Mrs. Fred Ingham, Seattle

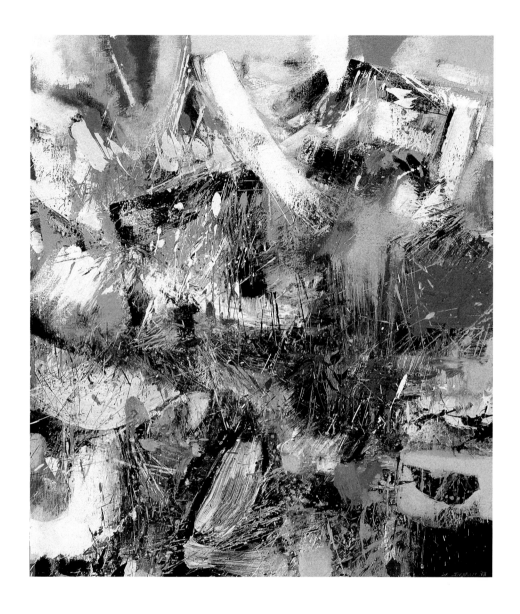

Broken Forms, 1993, acrylic on board, 23 x 20

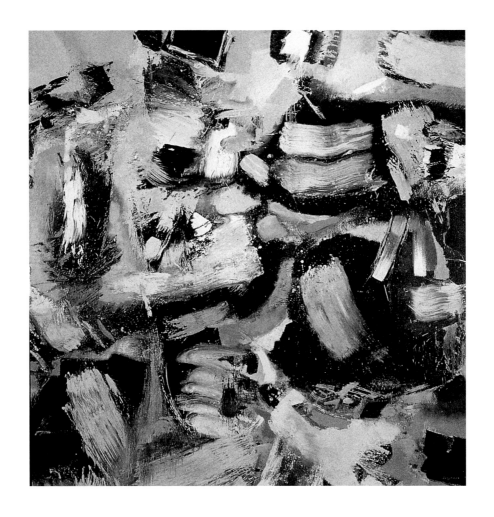

Tarifa, 1992, oil on canvas, 65 x 67
Roy, Beardsley and Williams, Attorneys at Law, Ellsworth, Maine

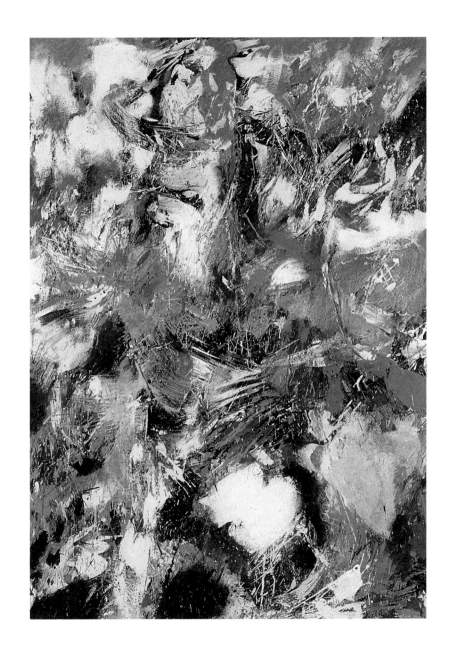

White Garden Sky, 1990, acrylic on paper, 45 x 34
Collection of Mr. and Mrs. Fred Lyman, Rancho de Taos, New Mexico

Yellow Rondo, 1990, acrylic on paper, 33 x 30
Collection of Colby College Museum of Art, Waterville, Maine

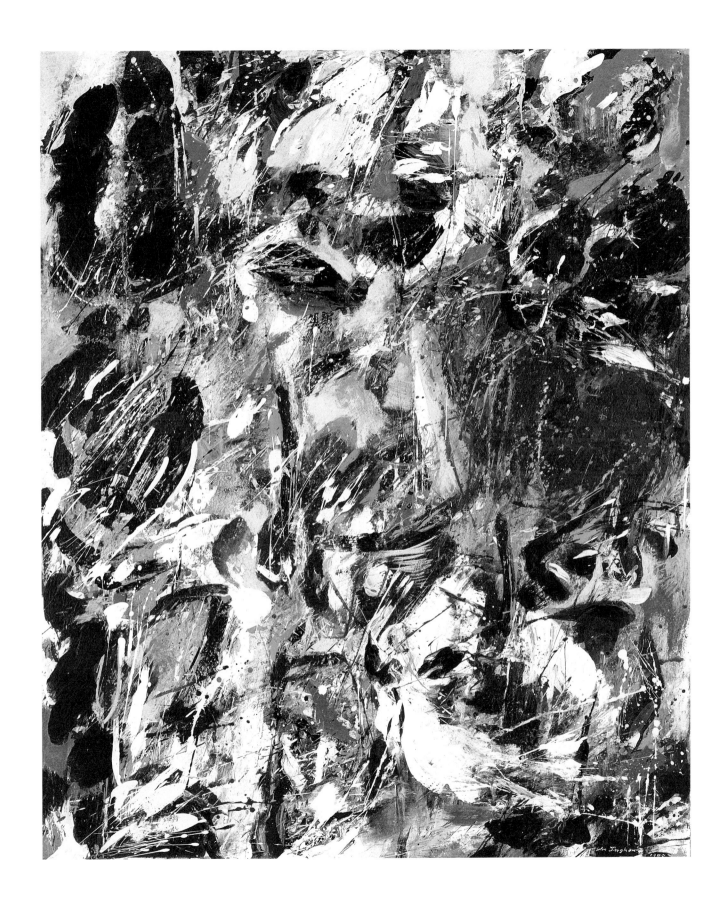

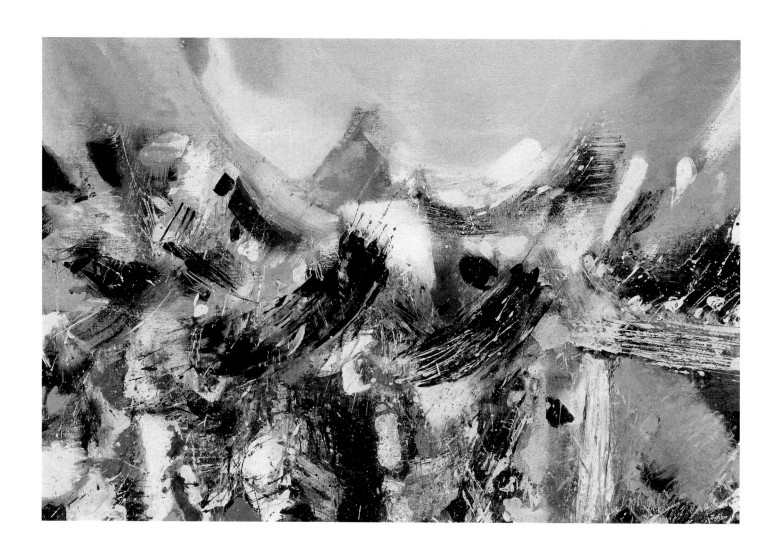

Drifting Forms, 1994, acrylic on canvas, 28 x 36
Collection of Dr. and Mrs. Peter Mansfield, Seattle

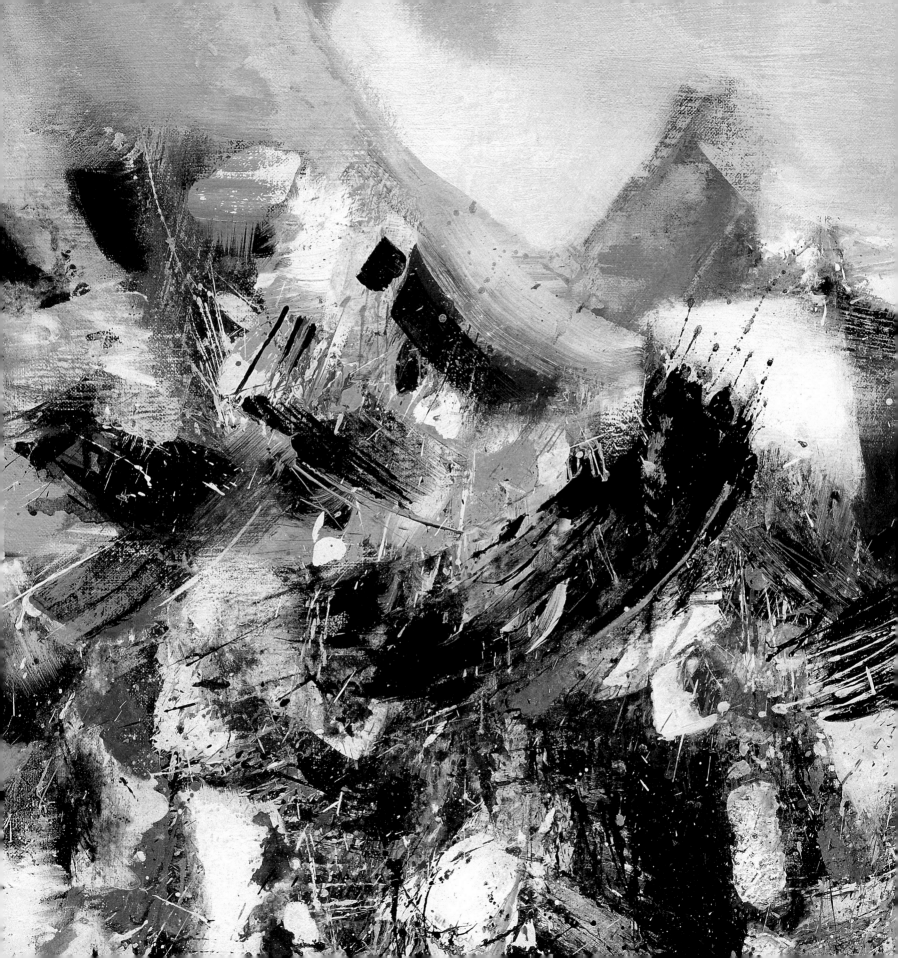

Poem to the Sea, 1993, oil on canvas, 24 x 70
Collection of Ms. Terry Macaluso, Seattle

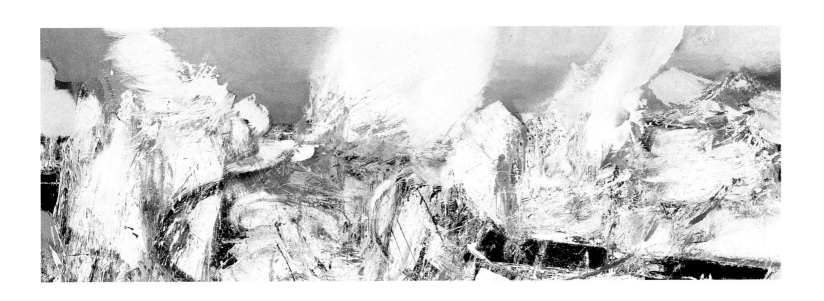

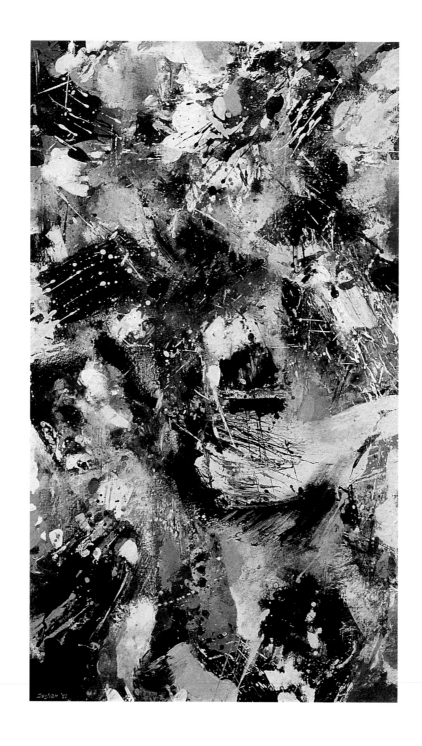

Celebration, 1994, acrylic on board, 30 x 20
Collection of Mrs. Helen Dean, Sun Valley, Idaho

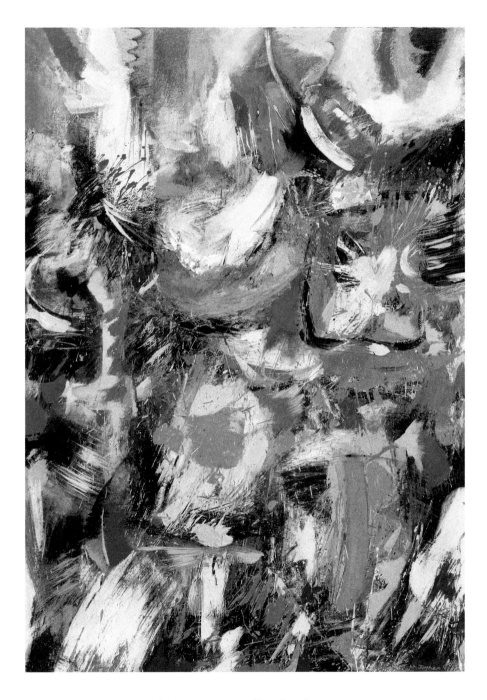

Prince Roman, 1992, acrylic on board, 33 x 23

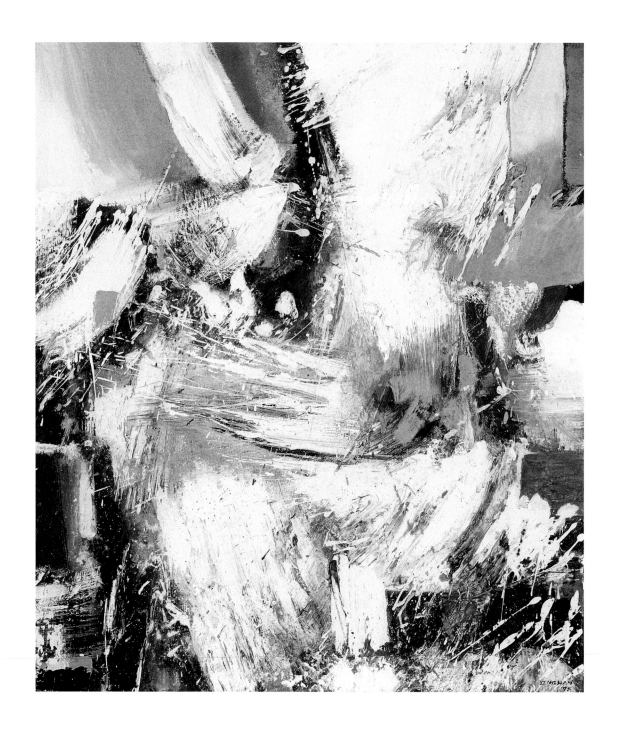

White and Red, 1995, oil on board, 16 x 14
Collection of Dr. and Mrs. Charles Gravenkemper, Seattle

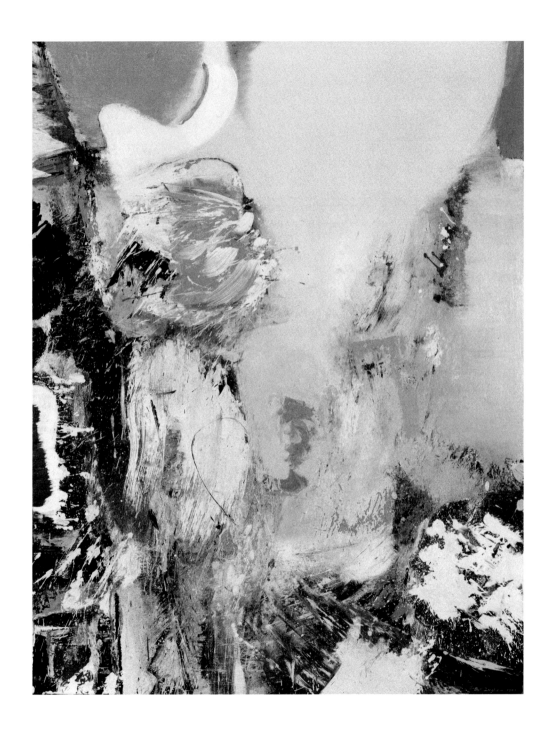

Lavender Blue, 1996, oil on canvas, 40 x 30

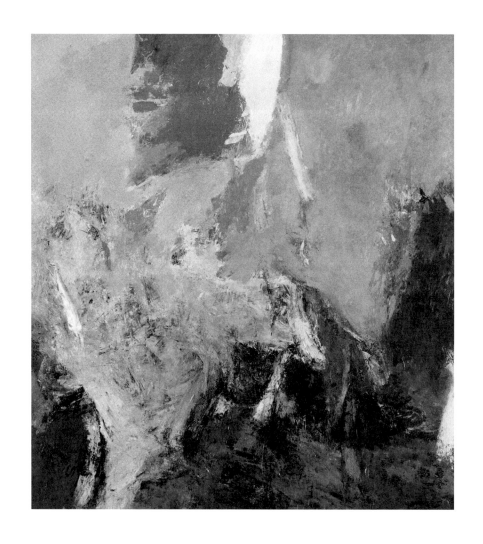

Fonteel 1, 1996, acrylic on canvas, 74 x 82
Collection of Robbins Company, Kent, Washington

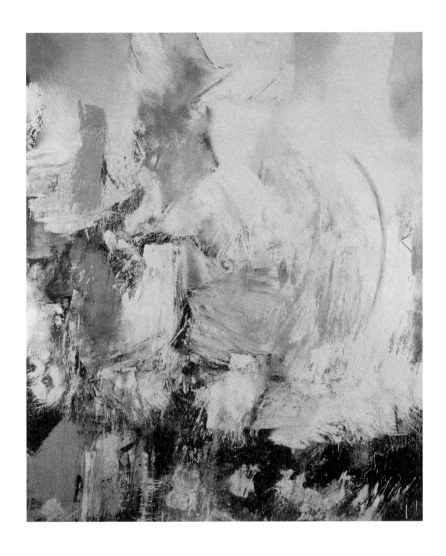

Fonteel 2, 1996, oil on canvas, 82 x 70
Collection of Richard Pruner, Bellevue, Washington

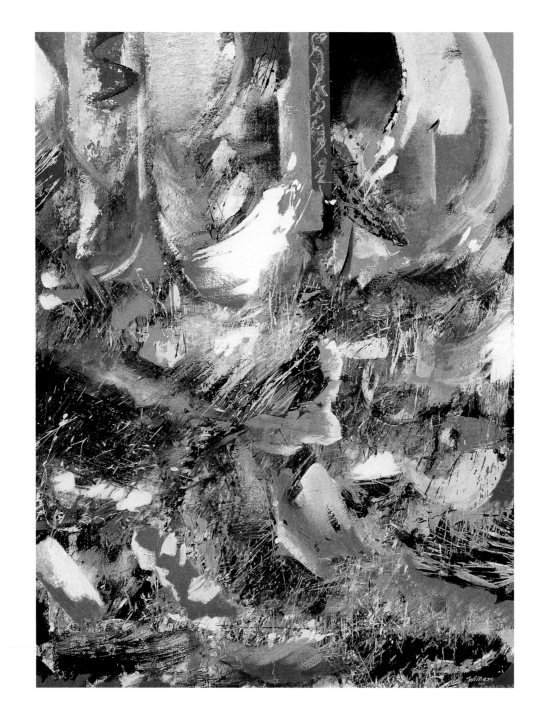

Arabesque, 1995, acrylic on board, 32 x 24

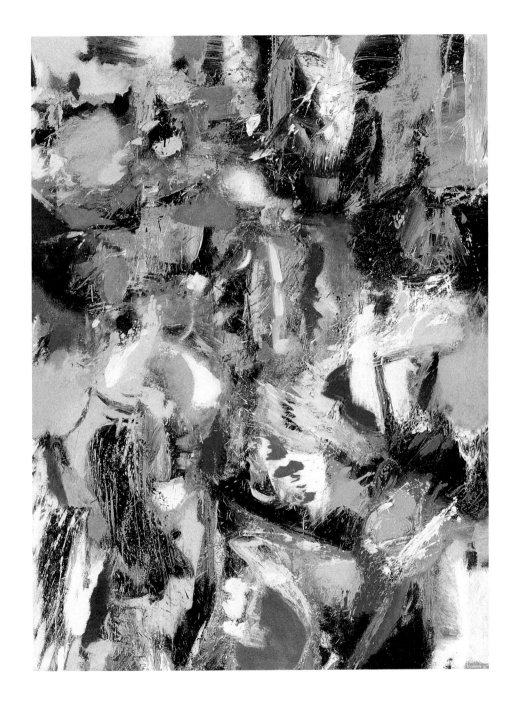

Beginning of Spring, 1994, oil on canvas, 46 x 38
Collection of Mr. and Mrs. Christopher Ingham, Sun Valley, Idaho

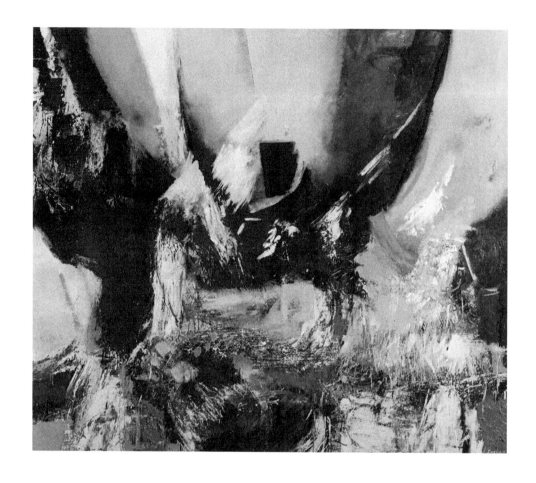

Red, 1996, oil on canvas, 74 x 82
Collection of Mr. and Mrs. Chap Alvord, Seattle

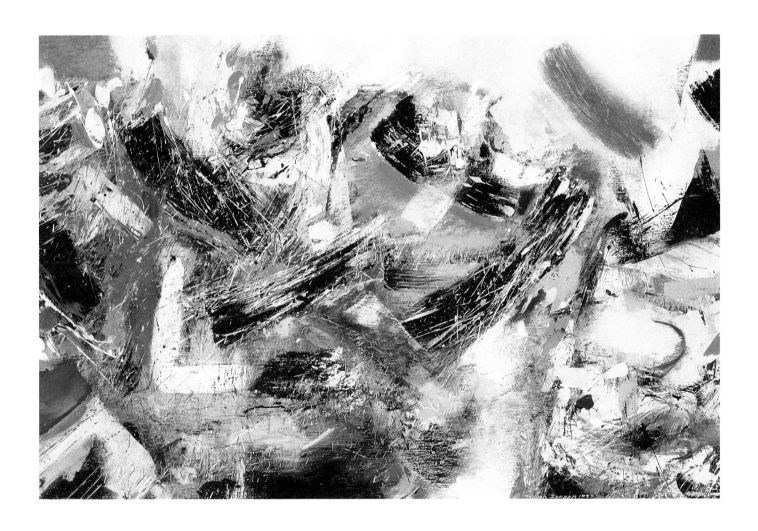

Atlantic Side, 1996, oil on canvas, 40 x 50
Collection of Mr. and Mrs. Frank Meyer, Kailua-Kona, Hawaii

Tambor, 1997, oil on canvas, 70 x 76
Collection of Preston, Gates & Ellis, Seattle

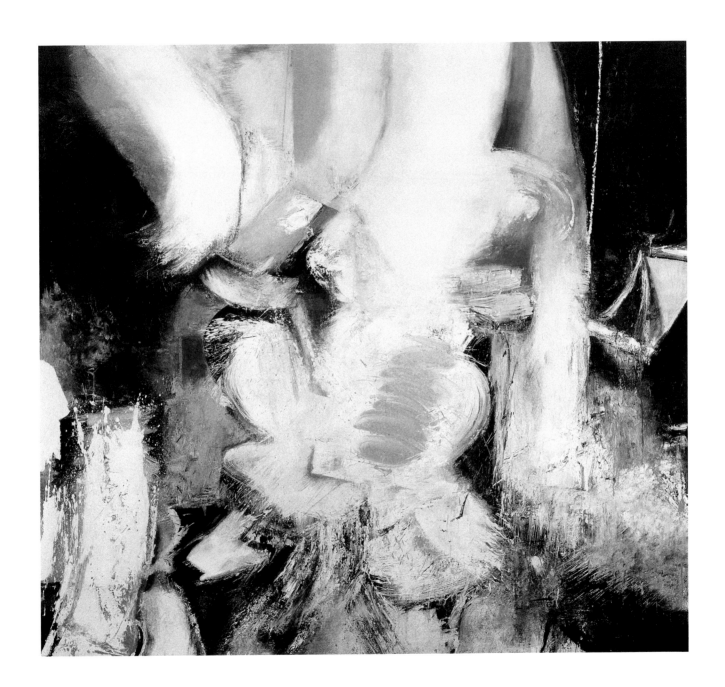

Lyric Blue, 1998, oil on canvas, 80 x 70

Light above the River, 1998, oil on canvas, 75 x 40

Midnight, 1998, oil on canvas, 37 x 29
Collection of Caroline Ingham, Princeton, New Jersey

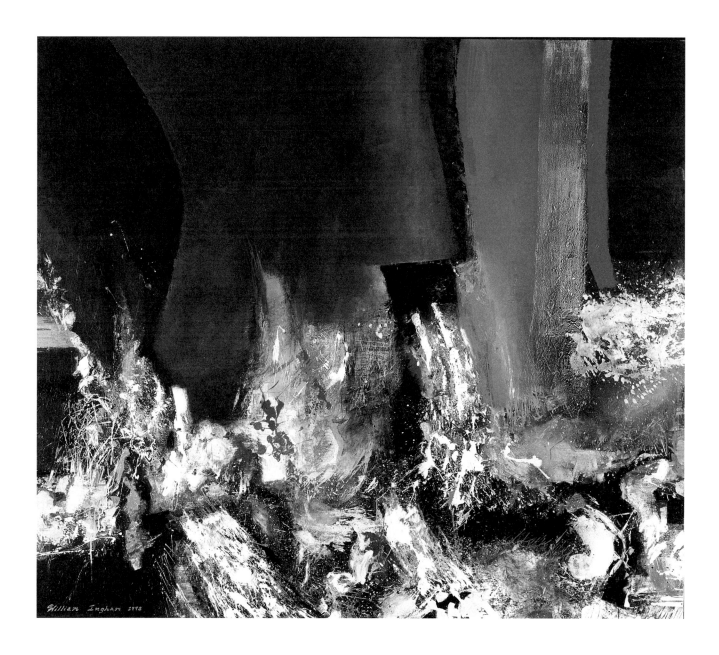

Thermopylae, 1998, oil on canvas, 65 x 75

Gray Scimitar, 2001, oil on canvas, 68 x 65

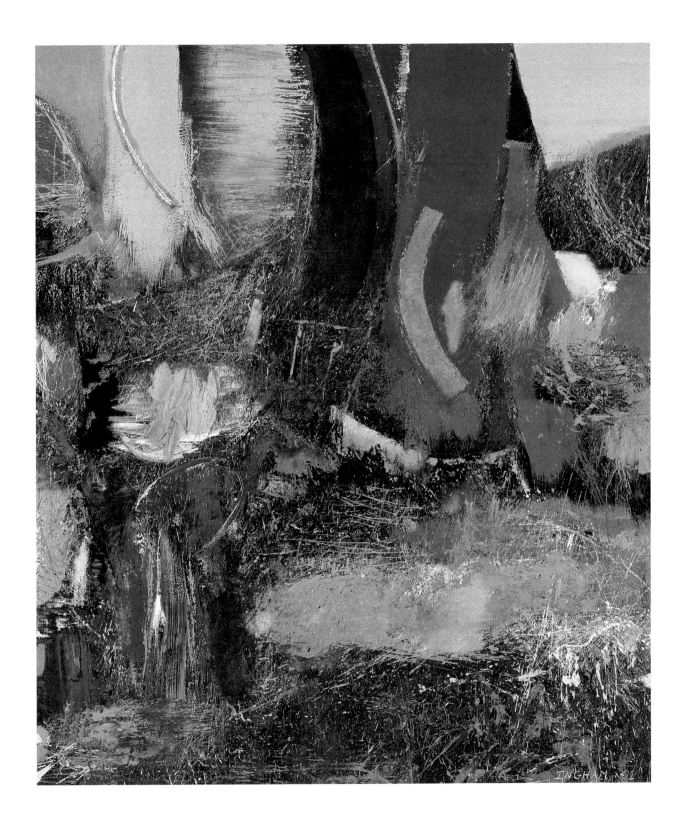

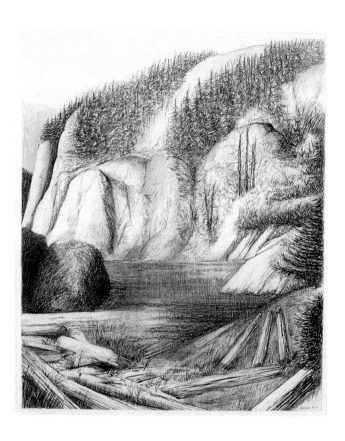

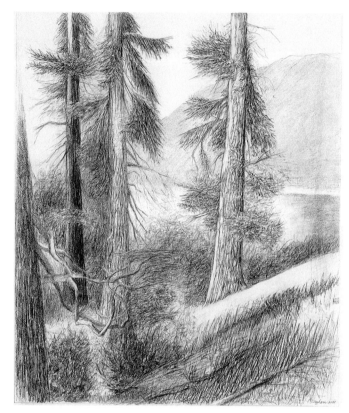

Deception Pass, Washington, 2000, graphite on paper, 16 x 13¹/₂

Trees, Deception Pass, 2000, graphite on paper, 16 x 13¹/₂

Blue Atlas Cedar, 2002, Prismacolor on paper, 22 x 17

Clear Cut, 2000, graphite on paper, 27 x 22

Old Orchard, Whidbey Island, Washington, 2000, graphite on paper, 16 x 14

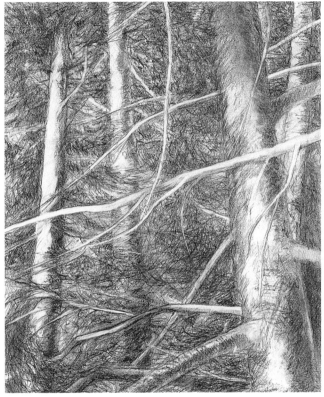

Eastern Cascade Rocks, 2001, graphite on paper, 27 x 22

Cedar Branches, 2002, graphite on paper, 12 x 10

Coast Range Study, 1999, graphite and colored pencils on paper, 20 x 32

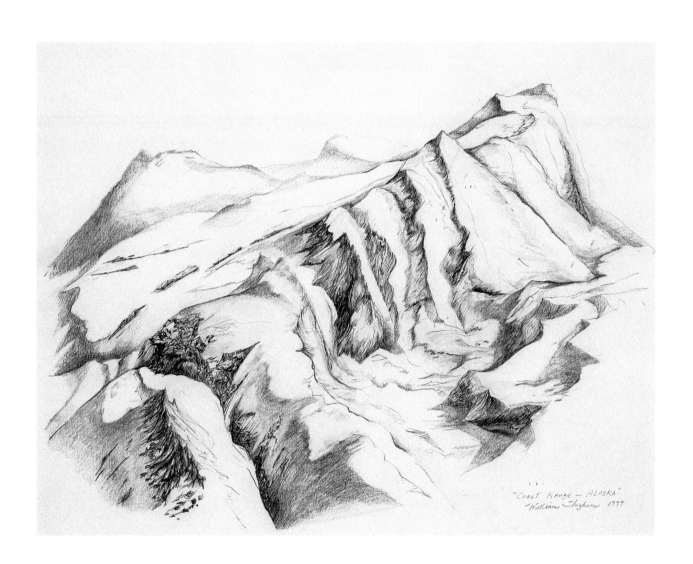

"Coast Range – ALASKA"
William Ingham 1999

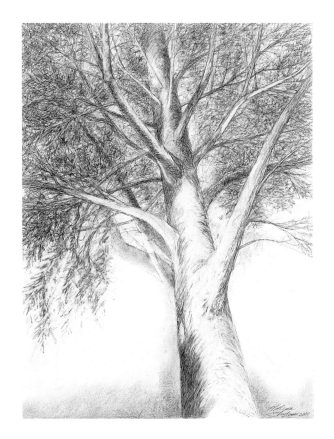

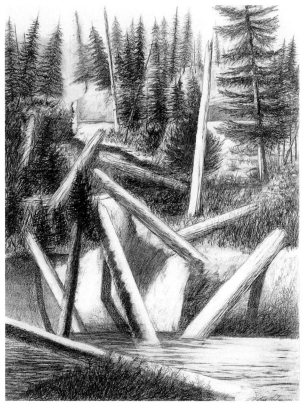

Study of an Atlas Cedar, 2001, graphite on paper, 22¹/₂ x 17

Mountain Tarn, 2001, graphite on paper, 22¹/₂ x 17

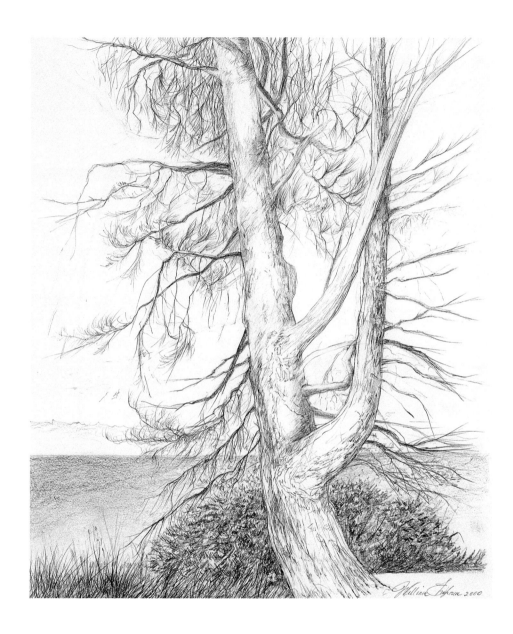

Old Cedar, Leschi Beach, Seattle, 2000, graphite on paper, 16 x 13^1/$_2$

Gates of Fire, 2001, oil on canvas, 66 x 87

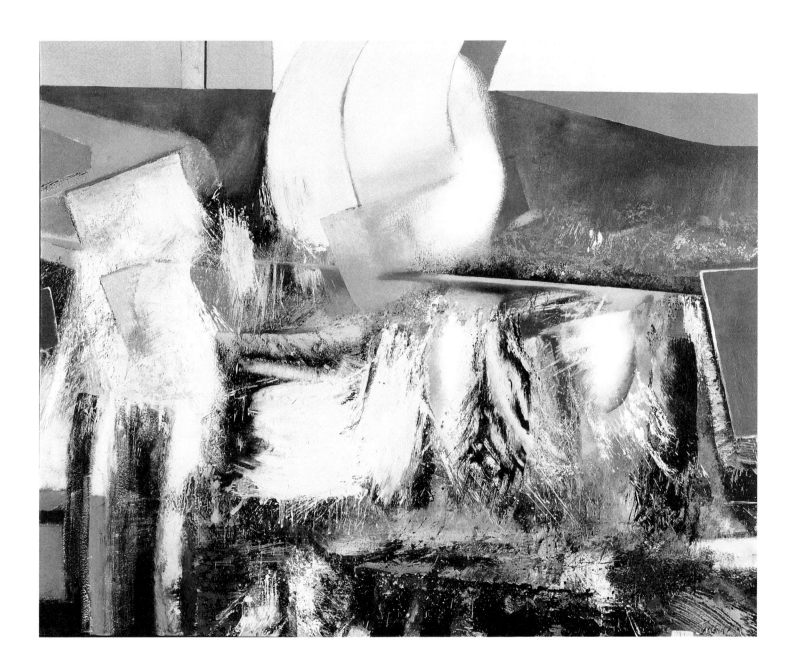

Ring of Fire, 2001, oil on canvas, 64 x 70

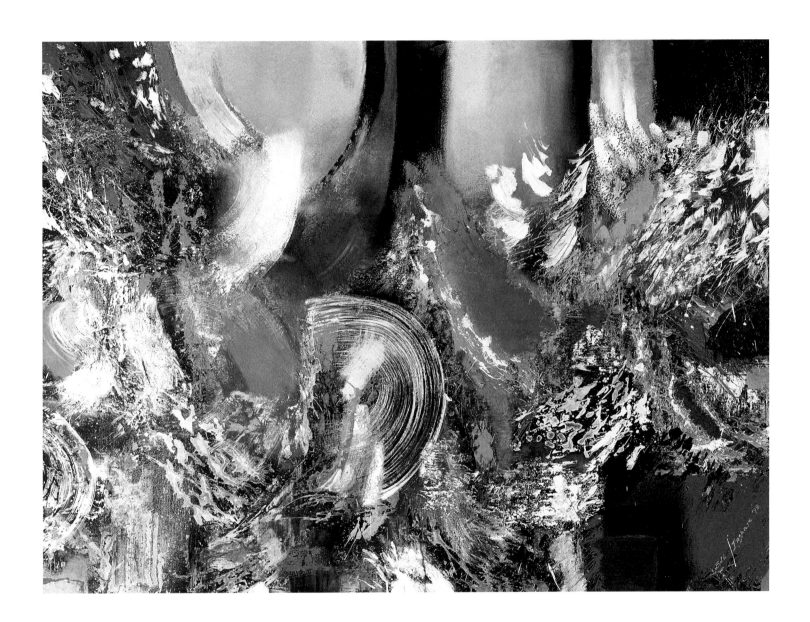

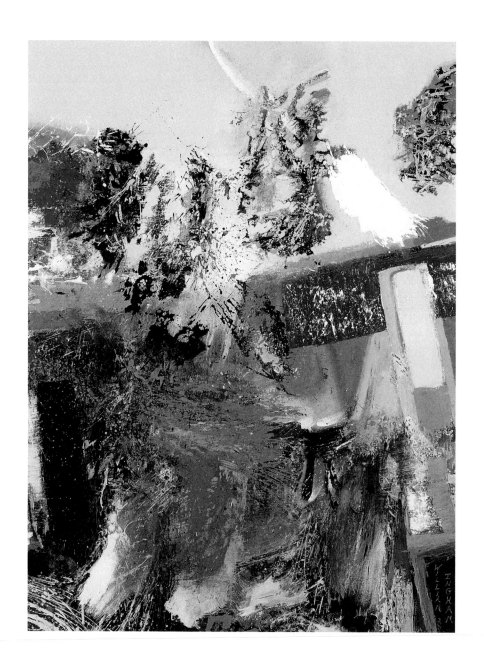

Azure Blue Vertical, 2001, oil on canvas, 48 x 36
Lakeview Cemetery Association, Seattle

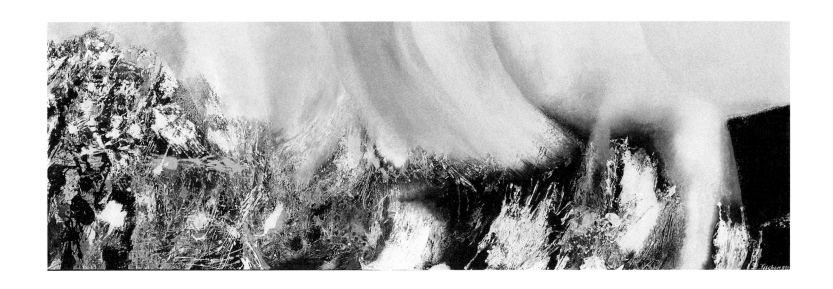

Azure Blue Horizontal, 2001, oil on canvas, 28 x 70
Lakeview Cemetery Association, Seattle

Cloudburst, 2002, oil on canvas, 48 x 36

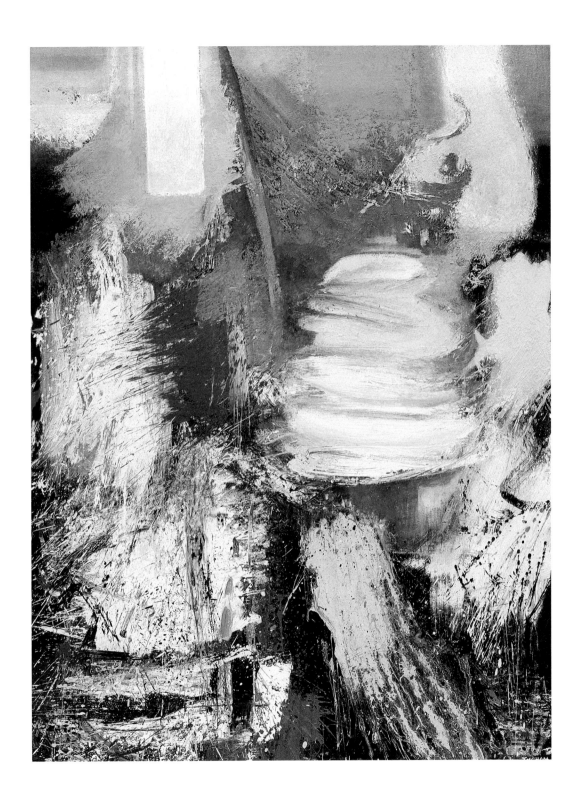

Vast Chasm, 2002, oil on canvas, 40 x 30

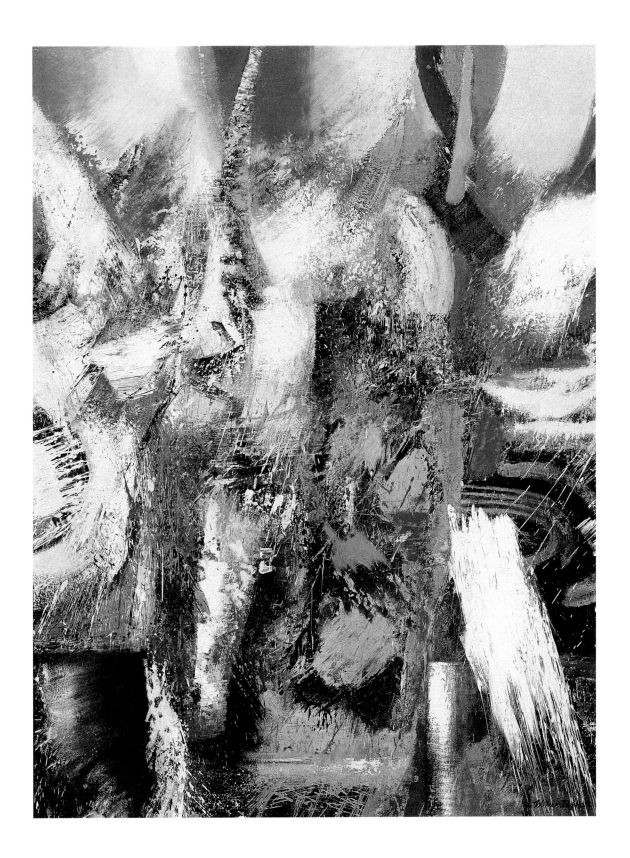

William Ingham with *Prarie Light*, 1974

CHRONOLOGY

Born William Partridge Ingham, April 17, 1944, Seattle,
to parents Amalia Partridge Ingham and Frederick Watson Ingham

Married Ruth Loker, 1966; three children, David, Fred, and Caroline

EDUCATION

1962 Lakeside School, Seattle, high school diploma

1966 Colby College, Waterville, Maine, Bachelor of Arts, philosophy, Arthur C. Pepper Prize in philosophy

1967 Case Western Reserve University, Cleveland, graduate-level philosophy classes

 Cleveland Art Institute, figure and design classes

1968 University of Washington School of Art, fifth-year undergraduate study

1972 University of Washington School of Art, Master of Fine Arts

SELECTED BIBLIOGRAPHY

Voorhees, John. "Part II of Thesis Show at Henry." *Seattle Times,* June 19, 1972.

Tarzan, Deloris. "Hust, Ingham and Guzak." *Seattle Times,* September 2, 1978.

Campbell, R. M. "The Charm of Calder." *Seattle Post–Intelligencer,* September 20, 1978.

Hackett, Regina. "Mason Still Has His Fun." *Seattle Post–Intelligencer,* February 7, 1980.

Kangas, Matthew. "At the Henry Gallery: 'Expressionism' Needs Definition." *Argus,* May 8, 1981.

West, Harvey, ed. *The Washington Year: A Contemporary View.* Seattle: Henry Art Gallery, University of Washington, 1982.

Hackett, Regina. "Arts and Entertainment." *Seattle Post–Intelligencer,* October 20, 1984.

Uyetake, Vern. "Strokes of Brilliance: Mixing Paint and Pleasure." *Oregon State University Daily Barometer,* April 12, 1985.

McCarthy, John. "Abstract Art Show Will Have Unusual Quality." *Lewiston Morning Tribune,* October 23, 1987.

Glowen, Ron. "Abstract Images and Objects." *Artweek,* October 30, 1987.

Kangas, Matthew. *Bumberbiennale: Decade of Abstraction 1979–1989.* Seattle: Bumbershoot, 1989.

———. "Jagged Edges." *Seattle Weekly,* February 15, 1989.

Hackett, Regina. "Seders 25th Anniv. Show Starts off with a Sterling Exhibit." *Seattle Post-Intelligencer,* May 16, 1991.

Albert, Fred. "Rambling On—New Addition Meant More than Adding Space to This Beloved Bellevue Rambler." *Seattle Times Pacific Magazine,* January 5, 1992.

———. "Cloistered—A New Interior Shows off the Fine Lines of This Leschi Home." *Seattle Times Pacific Magazine,* March 7, 1993.

Updike, Robin. "Sketchbook: This Season's Art Auctions Offer a Fine View of the Northwest Scene." *Seattle Times,* April 10, 1995.

Junius Rochester. *The Last Electric Trolley: Madrona and Denny Blaine Seattle, Washington Neighborhoods,* Tommie Press, Seattle Washington, 2002.

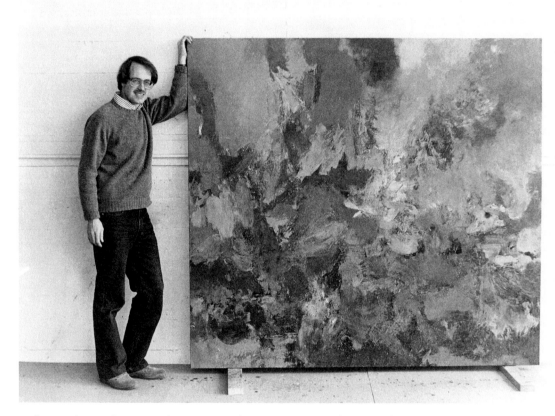

William Ingham with *Immanent Blue*, 1982, at Studio 503, Northwest Industrial Buildings, Seattle, 1982

SELECTED SOLO EXHIBITIONS

1978 *William Ingham: Recent Paintings,* Foster/White Gallery, Seattle

1980 Foster/White Gallery

1982 Foster/White Gallery

1983 Foster/White Gallery

1987 Gordon Woodside/John Braseth Gallery, Seattle

1988 Gordon Woodside/John Braseth Gallery

1991 Gordon Woodside/John Braseth Gallery

1992 Gordon Woodside/John Braseth Gallery

1993 Gordon Woodside/John Braseth Gallery

1996 Gordon Woodside/John Braseth Gallery

1997 Gordon Woodside/John Braseth Gallery

2002 Gordon Woodside/John Braseth Gallery

Installation view of Dootson/Calderhead Gallery
exhibition *Paintings: William Ingham, Knight Landesman, Jon
Zimmer,* Seattle, 1976; Robert Dootson (second from
right), *Sennebec,* 1976 (center)

William Ingham, Studio 505, February 2002

SELECTED GROUP EXHIBITIONS

1972 *Masters of Fine Arts II*, Henry Art Gallery, University of Washington, Seattle

1973 Polly Friedlander Gallery, Seattle

1974 Polly Friedlander Gallery

1976 *Paintings: William Ingham, Knight Landesman, Jon Zimmer*, Dootson/Calderhead Gallery, Seattle

1977 *Northwest Selections II*, Seattle Art Museum Modern Art Pavilion, Seattle Center, Charles Cowles, curator

1981 *The Mind's Eye: Expressionism*, Henry Art Gallery, University of Washington, Harvey West, curator

1983 *Contemporary Art of the Northwest*, Bellevue Art Museum, Bellevue, Washington, John Olbrantz, curator

1984 *Northwest Art from Corporate Collections*, Seattle Parks Department, Pier 70, John-Franklin Koenig, curator

1985 *Post Alley Exposé*, Italia, Seattle, Irene Mahler, curator

 25th Anniversary Exhibition, Gordon Woodside/John Braseth Gallery, Seattle

 Philip Jameson and William Ingham, Giustina Gallery, Oregon State University, Corvallis

1986 *Northwest Impressions: Works on Paper/1930 to the Present*, Henry Art Gallery, University of Washington, Chris Bruce, curator

1987 *Frontiers of Abstraction*, Prichard Gallery, University of Idaho, Moscow

1988 Gordon Woodside/John Braseth Gallery

1989 Gordon Woodside/John Braseth Gallery

 Bumberbiennale: Decade of Abstraction 1979–1989, Bumbershoot visual arts exhibition, Seattle Center, Matthew Kangas, curator

1993–2002 Gordon Woodside/John Braseth Gallery

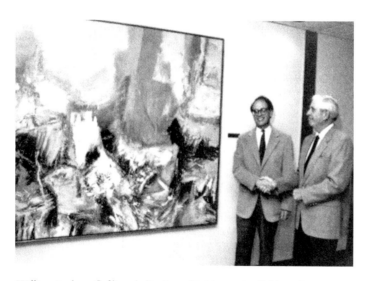

William Ingham (left) at dedication of *In Memory, David*, May 26, 1992, Swedish Medical Center, Seattle, with trustee Jim Scroggs

SELECTED PUBLIC COLLECTIONS

Accordia Northwest, Wells Fargo Bank, Seattle

Arthur Andersen, Seattle and Portland

Bank of America, Seattle

Colby College Museum of Art, Waterville, Maine

Cornish College of the Arts, Seattle

Dally Development, Seattle

Data and Staff Services, Seattle

Firstar Corporation, Minneapolis, Minnesota

Four Seasons Olympic Hotel, Seattle

Gaines/Halliday, Seattle

Genesee Partners, Bellevue, Washington

Holland & Hart, Boise, Idaho

Kennedy & Associates, Seattle

Lakeside School, Seattle

Lincoln Federal Savings & Loan, Seattle

Orbanco, a subsidiary of Security Pacific Corp., Portland, Oregon

Orthopedic Physicians, Seattle

Paccar, Bellevue, Washington

Park Place Building, Seattle

The Polyclinic, Seattle

Preston, Gates & Ellis, Seattle

Qwest, Seattle

Robbins Company, Kent, Washington

Roy, Beardsley & Williams, Ellsworth, Maine

Royal Trust, Vancouver, B.C.

SAFECO Insurance Companies, Seattle

Seattle Art Museum

Smith Barney Harris Upham, Santa Fe, New Mexico

Stusser Electric, Seattle

Swedish Hospital, Seattle

Swedish Medical Center, Seattle

Tacoma Art Museum

Williamson, Ferguson & Burdell, Seattle

Woodside & Woodside, D.D.S., Seattle

ACKNOWLEDGMENTS

The following people have given me indispensable help, assistance, and encouragement along the path to becoming an artist. At an early age, my brother Fred Lyman shared his love of Michelangelo, Leonardo, and other Renaissance artists. While working on paintings together, he taught me palette-knife techniques to build up color. He made the making of art interesting and fun. I am especially indebted to Professor Abbott Meader, who taught studio painting at Colby College, Waterville, Maine. His broad painting, like Elmer Bischoff's and Fairfield Porter's, inspired me to work and think in a similar direction, tying art to the Maine landscape. I also thank Professors James Carpenter, John Clark, and Robert Reuman, who encouraged my studies in the philosophy of art. I am grateful to Hugh Gourley, Director of the Colby College Museum of Art, for taking an interest in my work and providing material for this book.

At the School of Art, University of Washington, Alden Mason taught me the "tacit dimension" of the painting process: swirling paint on the canvas on the floor and allowing certain effects to build images; the point was not to worry about structure or cohesion but to make chance discoveries. Michael Spafford taught me the necessity of creating art from my deepest feelings, out of total brutal honesty. He encouraged me to forge images graphically, disregarding rules of traditional art making while valuing the rawest possible approach: sacrificing the known for the unknown. Kenneth Pawula taught me to balance emotion with structure because strength lies in balancing the two. At the same time he was sometimes surprised by my talent for pulling images out of a hat. Norman Lundin instructed me for three years in figure and landscape drawing. He left an indelible impression about the beauty of drawing for its own sake, demonstrated by copious illustrations from art history and his own work. Indeed, I learned that good form depended on good drawing, an indispensable discipline. Boyer Gonzales helped me with graduate school recommendations, and his pen and ink drawings of the San Juan Islands were captivating and memorable. John Thomas, although only a Visiting Professor for two years, influenced me with his intellectual approach to art, especially his Bauhaus methods of using careful color gradations. He introduced me to the absolutely revelatory writings of art psychologist Rudolf Arnheim. As well-dressed as a banker, Thomas followed exacting studio procedures and an almost scientific approach to create wild, spectacular paintings of jungle plants.

I also thank the gallery owners and consultants mentioned in this volume, who furthered the sale and acceptance of my work in the Seattle area. In particular I am grateful to Robert Dootson for showing my work at his new gallery and introducing me to galleries and artists in New York; Susan Asia for bringing commission work my way; and Gordon Woodside and John Braseth for serving as my gallery and supporting the publication of this book. I also thank Tom Blue and his fine framing crew at Plasteel Frames for their excellent work over the years. Finally, my wife, Ruth, and my family gave me constant support and encouragement along this sometimes complicated road to being an artist.

—William Ingham

PHOTO CREDITS

Every effort has been made to identify all the photographers. In addition to the photographers and institutions credited below by page number, many individuals worked hard to bring together the beautiful reproductions in this book. They include Richard Nicol and Chris Eden, who worked with William Ingham to take numerous photographs over time. Employees of institutions and galleries as well as artists and private collectors smoothed the way for permissions, including Artists Rights Society; John Braseth and Tony Erwin, Gordon Woodside/John Braseth Gallery; Francis Celentano; Heidi B. Coleman, rights director, Visual Artists and Galleries Association, Inc.; Jan Day, Virginia and Bagley Wright Collection; Dedalus Foundation, Inc.; Janae Huber, Tacoma Art Museum; Melissa Klotz, assistant registrar, and Catherine Walworth, interim permissions director, Seattle Art Museum; Tom Landowski, director, Foster/White Gallery; Achim Moeller, Achim Moeller Fine Arts; Beth Sellars, collection manager, and Kim Baker, registrar, Portable Works Collection, Seattle Arts Commission.

35mm: 16 (right), 24

Art and Photo Reproduction: 60-61, 97

Francis Celentano: 9 (left)

Colby College Museum of Art: 59

Chris Eden: 17, 21 (left, right), 44, 47-50, 52

Foster/White Gallery: 16 (left)

Tom Harris: 18 (left), 25 (left, right), 27, 56, 57, 63, 64, 67, 69, 71

Henry Art Gallery: 11 (left)

William Ingham: 8 (left), 9 (right), 100, 101

Paul Macapia: frontispiece, 14, 26 (right), 30 (left)

Ed Marquand: 42, 68

Richard Nicol: 11 (right), 13, 15, 18 (right), 19, 20, 22, 28-30 (right), 31, 32 (all), 33-36, 40-43, 45, 54, 55, 65, 66, 75-78, 81-84 (left, right), 86 (left, right), 87 (left), 89, 90 (left, right), 91-97

Pat Oakley: 98

Guy Orcutt: 11 (left)

Seattle Arts Commission: 10

Kim Steele: 37, 102

Swedish Medical Center: 104

Ken Wagner: 16 (left), 51, 69, 80

Tom Woodward: 72, 73